FOR LOVE

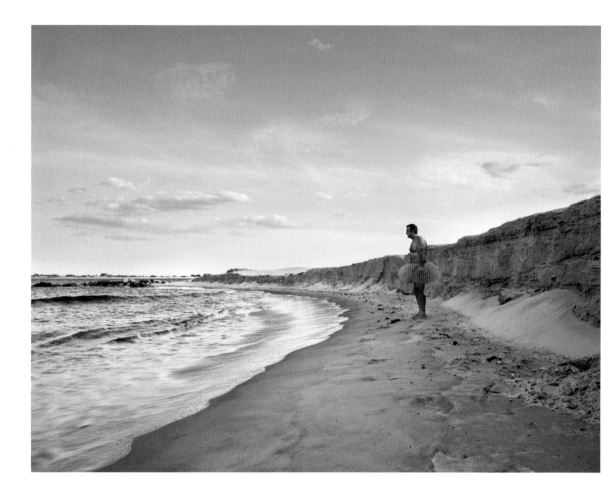

FOR LOVE

25 HEARTWARMING CELEBRATIONS OF HUMANITY

ALICE YOO & EUGENE KIM

OF MY MODERN MET

CHRONICLE BOOKS

SAN FRANCISCO

Library of Congress Cataloging-in-Publication Data

For love : 25 heartwarming celebrations of humanity
[compiled by] Alice Yoo and Eugene Kim.
pages cm
ISBN 978-1-4521-3984-5
1. Portrait photography. 2. Survival. 3. Resilience (Personality trait)
I. Yoo, Alice, 1976- II. Kim, Eugene, 1982-

TR680.F6455 2016
770.92–dc23

2015014534

ISBN: 978-1-4521-3984-5

MANUFACTURED IN CHINA.

MIX
Paper from
responsible sources
FSC™ C104723

Design by Sara Schneider

10 9 8 7 6 5 4 3 2 1

CHRONICLE BOOKS LLC
680 SECOND STREET
SAN FRANCISCO, CA 94107

WWW.CHRONICLEBOOKS.COM

DEDICATED TO ORDINARY PEOPLE
WHO DO EXTRAORDINARY THINGS.
YOUR COURAGEOUS ACTS OF LOVE
MAKE THIS WORLD A BETTER PLACE.

Contents

Acknowledgments

We'd like to personally thank the photographers who have generously allowed us to share their personal stories with you. They are the ones behind the lens, crafting each scene like a director, choreographing every last detail. Without them, none of these photos would have been made nor would any of these amazing stories have been shared.

To our family—Sammy, Annie, Grace, Carol, Keith, and Burt: thank you for believing in us over the years. With your unwavering support, we have been able to make the leap from curating an art blog to writing this book.

To our My Modern Met writers—Pinar, Katie, Sara, Jenny, and Anna—the website would not be filled with these heartwarming stories without the hard work and dedication you've put into our site each and every day.

And finally, to our loyal followers: with your support, all of this has been made possible. We are forever in your debt and, in return, we humbly vow to be your voice.

INTRODUCTION

In a world filled with cynicism and a 24-hour news cycle infiltrated with stories of war, crime, and celebrity gossip, we wanted to tip the balance and shine a spotlight on stories filled with positivity and hope.

Over the past seven years, we've been dedicated to finding the best visual stories for the millions of viewers of our art blog, My Modern Met (www.mymodernmet.com). After sifting through the most popular and touching content, we've compiled this collection of the twenty-five most compelling visual stories that are sure to warm your heart.

The heroes of these stories are ordinary people who do extraordinary things. People who are selfless in their deeds and courageous with their actions.

Take, for example, Bob Carey, who took photographs of himself wearing a pink tutu to bring joy to his wife, who had cancer. The hilarious series showed support for his ailing wife and inspired thousands, if not millions, of people who have cancer or know someone who does, through this loving act.

Or take the story of Miles Scott, also known as Batkid, the young cancer survivor who dressed as Batman's sidekick and "saved" the city of San Francisco. Thanks to the Make-A-Wish Foundation, Batkid's clever, creative, and heart-warming story inspired people all over the world.

Then there's Donald and Dorothy Lutz. For their sixty-first wedding anniversary, their daughter-in-law Lauren Wells arranged a present they'd never forget, a heartfelt and memorable photo shoot based on the charming Pixar movie *Up*. The Lutz's original wedding photographer had stood them up decades before, so after more than sixty years together, the couple finally got the wedding portraits that they deserved.

These remarkable visual stories will introduce you to people who have risen to the occasion and gone well beyond the call of duty in the name of love. We've had the privilege of writing about these incredible tales, and they've not only brought a smile to our faces, they've helped us realize what a selfless act looks like. Warm, thoughtful, and creative—these stories make this world a better place. They rise above the endless clutter, restoring our faith in humanity.

–ALICE YOO *&* EUGENE KIM

MY MODERN MET

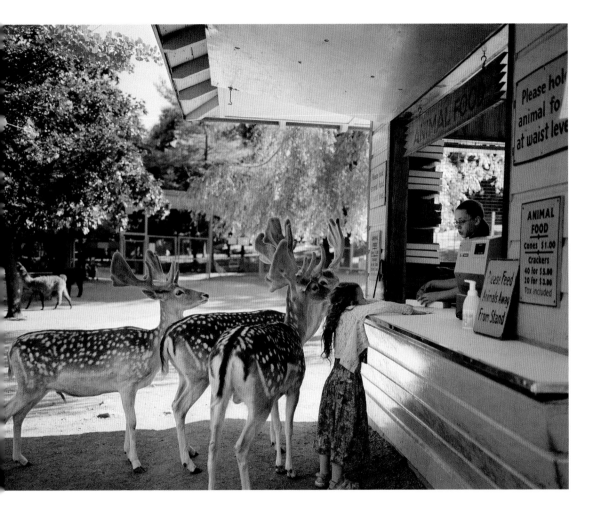

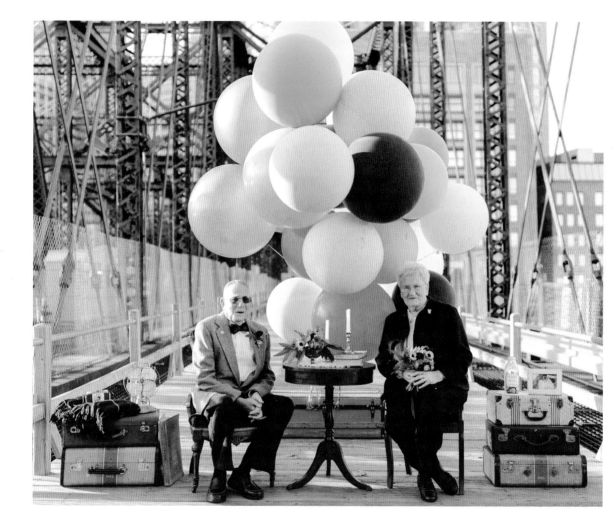

"UP"–THEMED
Anniversary Shoot

CAMBRIA GRACE

After being married for an incredible sixty-one years, Donald and Dorothy Lutz finally got the wedding photos that they'd always dreamed of. As a special holiday present, event designer Lauren Wells teamed up with photographer Cambria Grace to create some memorable anniversary photos for her beloved grandparents, "Nina and Gramps." According to Lauren, the two have never taken their rings off, remain the best of friends, and have just one picture from their wedding day because their photographer stood them up.

Using the classic Pixar movie *Up* as inspiration, Lauren worked with a team of creatives to make a unique gift. Cambria Grace handled the photography, Caroline O'Donnell from Wildfolk Studio was in charge of the flowers, and Becky Brackett's Pop & Circumstance arranged the vintage props.

The photo shoot took place on Boston's Old Northern Avenue Bridge, and everything came together perfectly. "Nina cried when she got handed her beautiful bouquet," Lauren says.

On Christmas, Lauren presented the couple with the gift. "We surprised them with an album on Christmas morning. It was pretty amazing," Lauren says. "Nina's jaw dropped, and she burst into silent tears. She kept saying 'Oh my gosh!' over and over again. Gramps just smiled a huge smile and watched Nina with so much love. As they flipped through the book, every photo caused another heartfelt reaction. It was a really happy, emotional, and sweet scene."

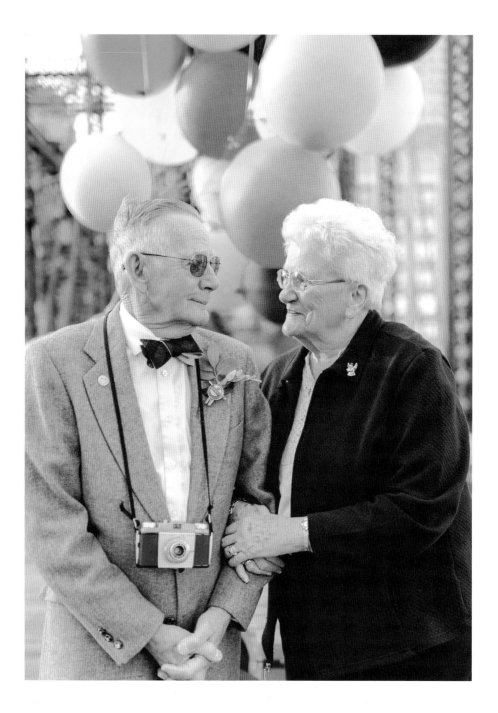

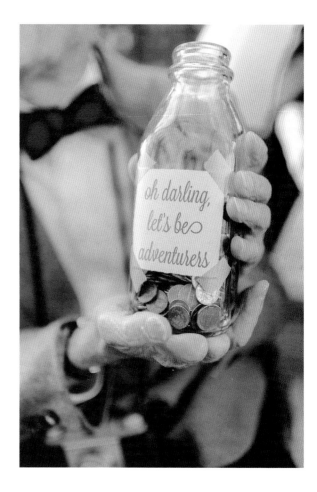

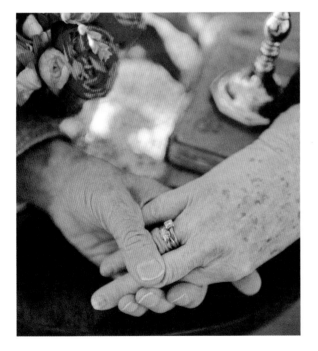

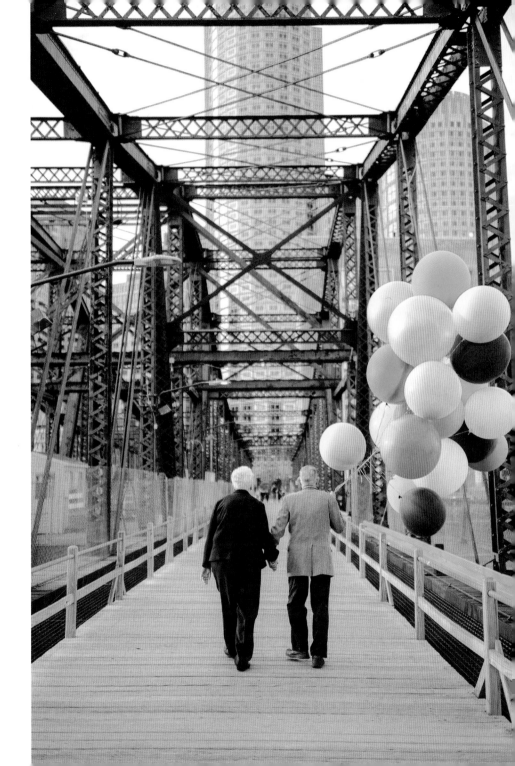

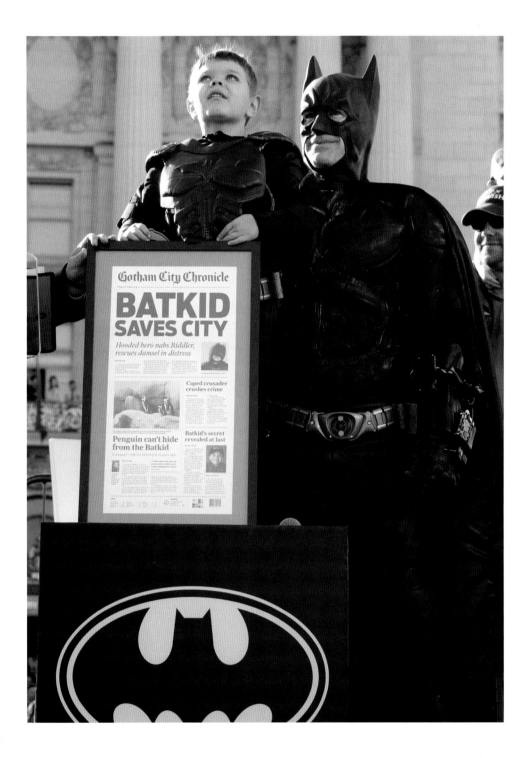

BATKID

SAVES SAN FRANCISCO

PAUL SAKUMA

Five-year-old Miles Scott had a day he'll never forget. Battling leukemia since he was just eighteen months old, Miles fulfilled his dream of becoming Batkid, sidekick to Batman, with the help of Make-A-Wish Foundation and thousands of supportive fans living in San Francisco.

Patricia Wilson, the Make-A-Wish Foundation's Bay Area executive director, thought a few hundred volunteers would come out to support Batkid. But, after the story went viral, an estimated 25,000 people showed up for Batkid's special day. Even the media and city officials were in on the act as San Francisco mayor Ed Lee gave the key to the city to Miles. *The San Francisco Chronicle* distributed special edition newspapers in Union Square with the headline "Batkid Saves City." The wish became one of the most elaborate events ever staged by Make-A-Wish.

"Miles's wish inspired the kind of generosity and goodwill that is uncommonly rare," Patricia says. "People told us that it was a day that made them 'proud to be a San Franciscan,' and that the wish 'restored their faith in humanity.'"

"It's really neat to see how many people have gotten together for a stranger they don't know, and show support for; it's heartwarming," says Miles's father, Nick Scott.

What made the story so huge? "The answer cannot simply be boiled down to one thing," says Patricia. "But the one thing that made the experience overwhelmingly positive for so many people was that it was pure."

Miles finished his treatments and his cancer is now in remission.

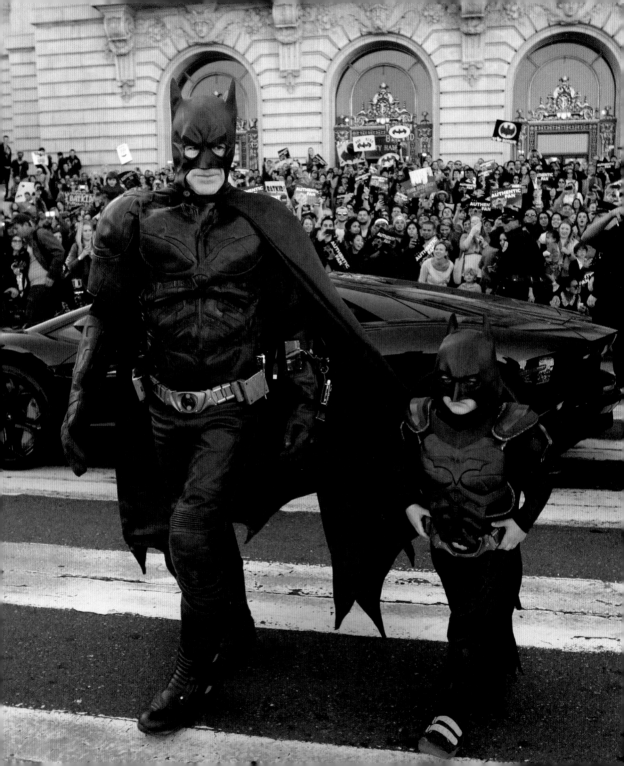

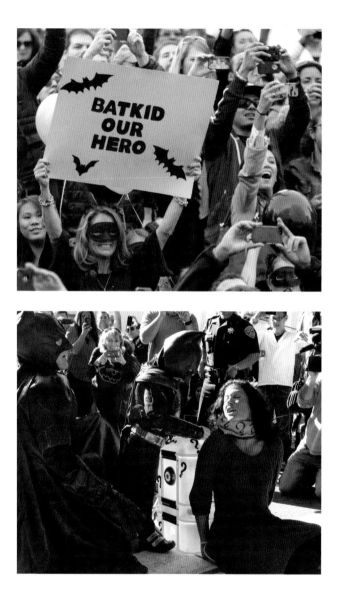

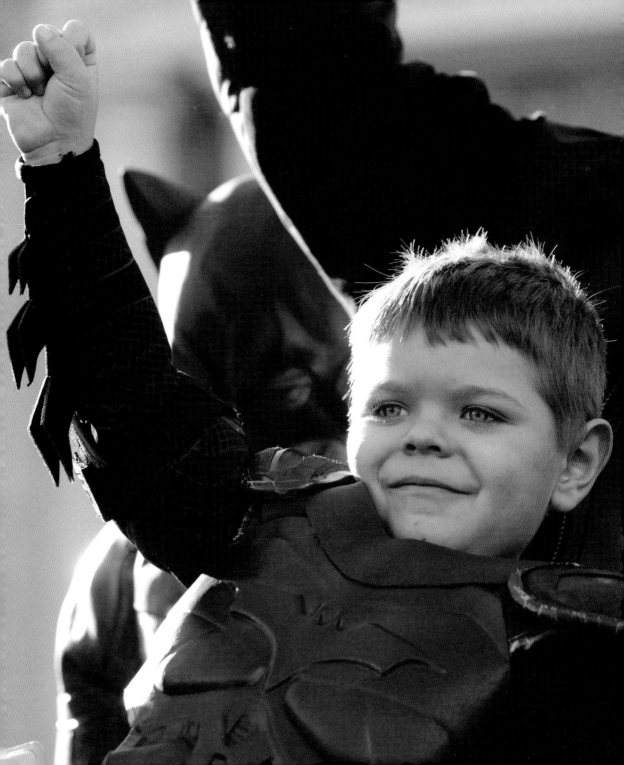

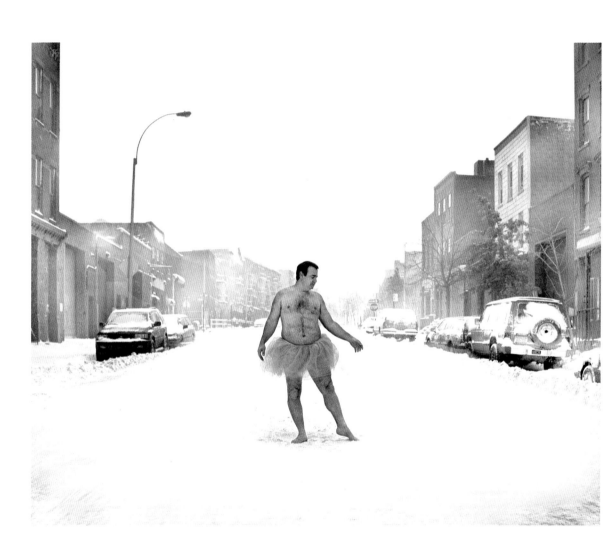

a husband
IN A PINK TUTU

BOB CAREY

In 2003, Linda Carey was diagnosed with breast cancer. Stricken by the news, her photographer husband Bob Carey dedicated his photo series *The Tutu Project* to cheering her up.

The photographs feature Bob wearing nothing but a pink tutu in humorous situations like frolicking in the snow, lying in the center of Times Square, or standing among rows of corn in the middle of a field. The visual story was shared around the world as millions of viewers were touched by Bob's act of love. The couple received thousands of e-mails, and though it's hard to narrow down which one touched them the most, Linda remembers one in particular: "An eleven-year-old girl thanked us for making her mother smile as she went through chemotherapy. My heart was touched, and tears were flowing."

Some say laughter is the best medicine, and this project is evidence that Bob and Linda have really embraced that motto. As Bob says, "Oddly enough, cancer has taught us that life is good; dealing with it can be hard, and sometimes the very best thing—no, the only thing—we can do to face another day is to laugh at ourselves, and share a laugh with others."

Linda's cancer reoccurred in 2006, and she has been fighting the disease ever since. The Careys have dedicated Bob's photography to raising money for breast cancer research.

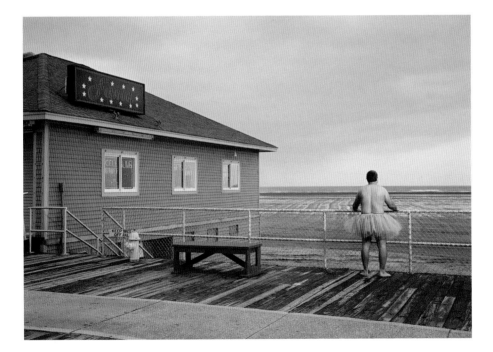

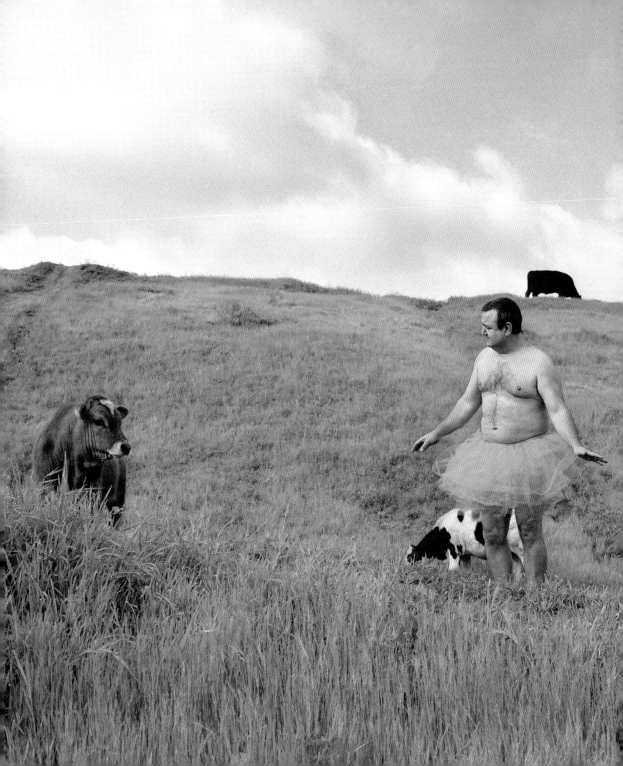

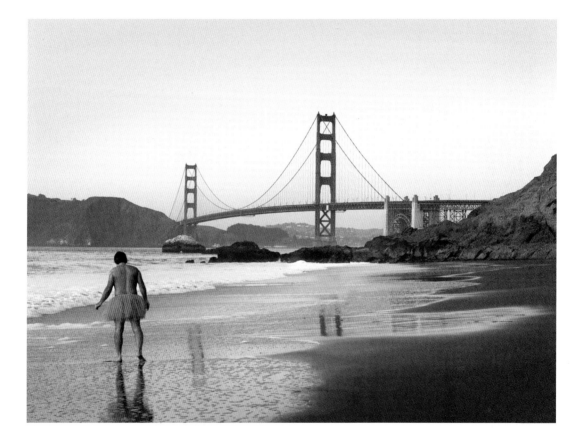

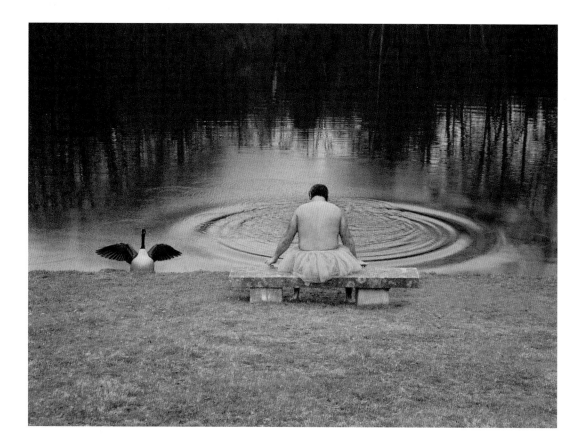

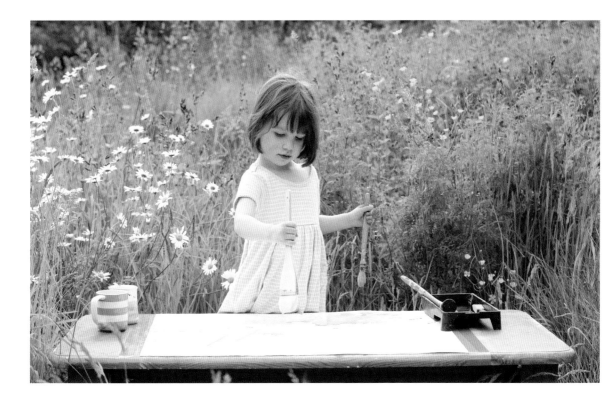

a little girl's
WORKS of ART

ARABELLA CARTER-JOHNSON

Iris Grace, who was diagnosed with autism when she was two and has dealt with speech issues her whole life, found a beautiful way to express herself. She paints. The five-year-old, who lives in the U.K., has an incredible concentration span of about two hours per session, and has an understanding of colors and how they interact with each other that is far beyond her years.

Iris's mother, Arabella Carter-Johnson, believes that painting is her daughter's calling. "It came about because I was educating her at home and I was trying to follow the national curriculum. Drawing and painting were some of the things on my hit list to do with Iris."

The young girl works side by side with her therapy cat, Thula. During her painting sessions, Thula sits right next to her, watching each stroke, and giving her a special dose of warmth and affection. "Whatever activity we are doing, Thula is there and wants to help and be involved, be it painting, bike rides, puzzles, or drawing," Arabella explains. "She offers Iris companionship and friendship."

Iris creates gorgeous paintings filled with dreamy colors and fascinating textures. The soothing works, many of which are inspired by nature, are reminiscent of Monet's impressionist paintings. Iris's work has been sold to private collections in the U.K., the United States, Europe, and South America. With autism currently affecting around 100,000 people in the U.K., Iris's family shared her story with the hope that it would bring awareness to the disorder. "Her art has opened up our eyes to the possibilities in her life and of others on the spectrum, to follow their 'spark' and to see the wonderful things that can happen," Arabella says.

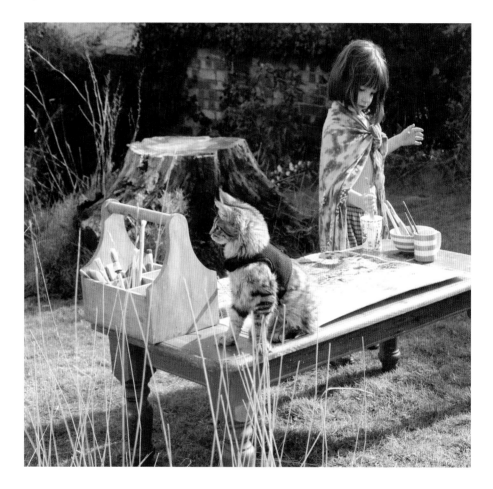

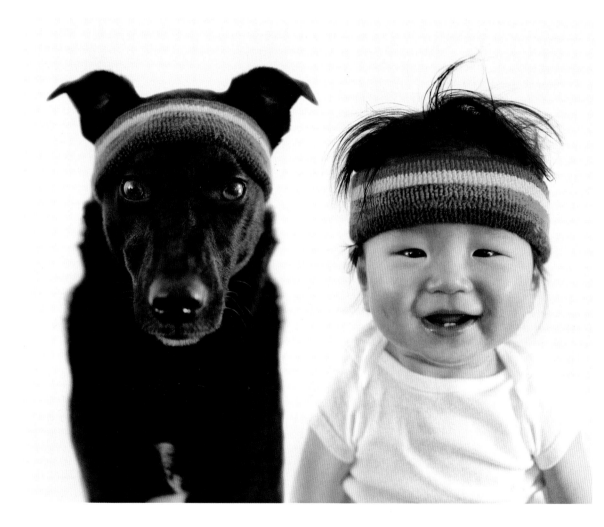

a baby AND
A RESCUE PUP

GRACE CHON

Lifestyle photographer Grace Chon is used to taking photos of other people's babies and pets, not her own. Lucky for us, she turned the camera on her ten-month-old Chinese-Korean baby, Jasper, and their seven-year-old rescue dog, Zoey, putting them side by side in one of the most adorable series of portraits you'll ever see.

"I've always dressed up my dogs in silly costumes, so naturally when I had a baby I started collecting some hats for photos," Grace explains. "One day I put one on Zoey, and I had the epiphany that baby hats look ridiculously adorable on dogs, too!"

Though you wouldn't be able to tell in these photos, Zoey is very shy. "She had a difficult start in Taiwan," says Grace. "She was born in front of a store, and the owner washed her and all her siblings into a gutter. A schoolgirl walking by witnessed this, scooped up all the puppies, and carried them home. She contacted the Animal Rescue Team in Taiwan, and they prepared the puppies and mom for adoption in the States.

"I picked up Zoey at LAX, and the rest is history. She can be very afraid of new things, so I was surprised how much she took to wearing clothing. I know it sounds crazy, but I think it builds her confidence when she wears clothes. She does a happy dance when the props come out, and she loves posing for the camera!"

Jasper also exudes happiness. "Jasper is seriously the happiest baby ever," says Grace. "He's been smiling for photos since the day he was born."

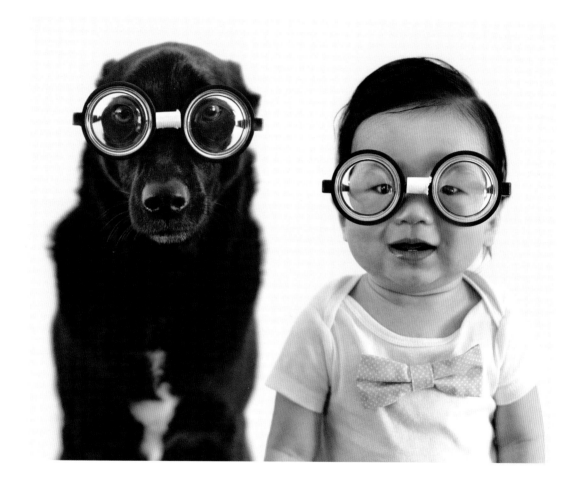

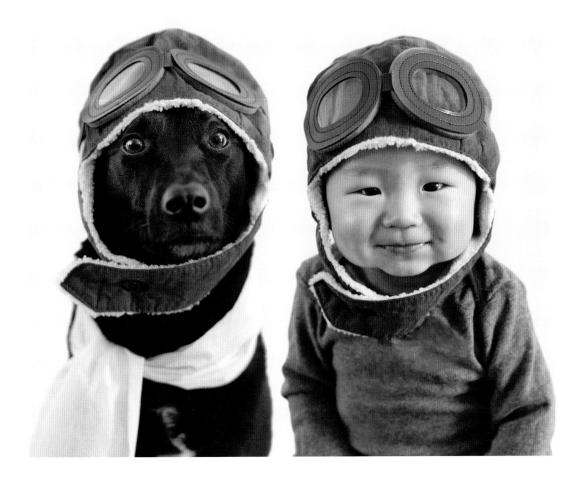

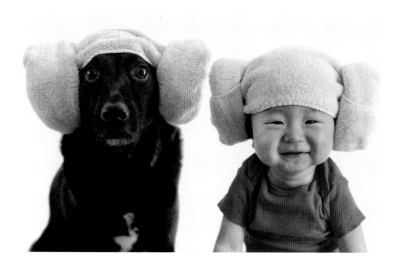

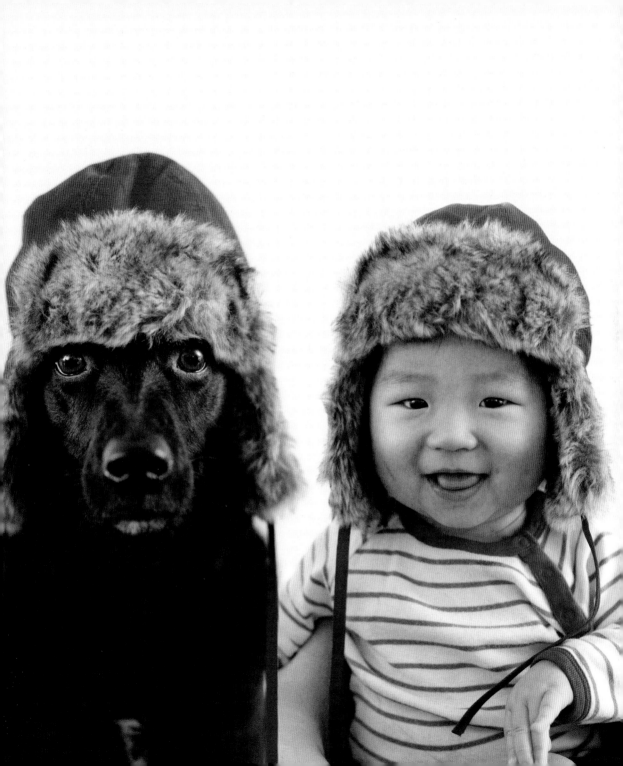

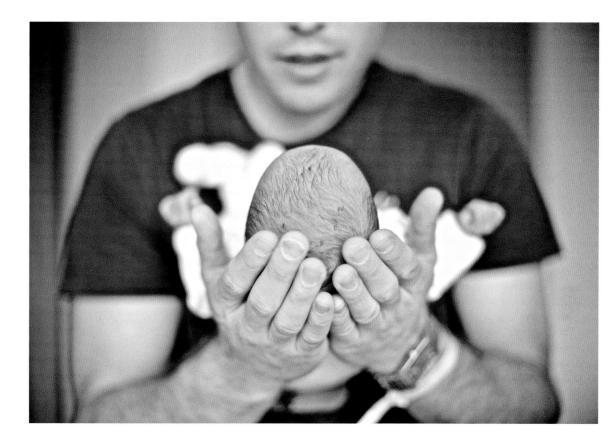

NEW DADS

JAYDENE FREUND

Many fathers say the happiest moments of their lives were the moments their children were born. Jaydene Freund of Cradle Creations captures these moments in a photo series that documents new dads' expressions right before or right after their partners have given birth. The touching images reveal the many different emotions that play out in the birth room.

Jaydene hopes to show that a birth isn't just a journey for a mother; it's an emotional journey for a father as well. The photographer shot sixty births at hospitals and homes in Vancouver, British Columbia. And even after witnessing all those births, he still feels mesmerized by the incredible bonds between mother, father, and child. "Each birth has its own unique set of emotions," he says. "I've captured laughter, tears, frustration, boredom, bonding, strength, weakness, relief, and joy.

"There are always tears at a birth. Often they are tears of joy, and sometimes they are tears of discouragement and defeat. During labor, a woman pushes herself further than she ever thought possible, and her partner is by her side, supporting her physically, whispering encouragement in her ear, falling more deeply in love with her, admiring her strength, and celebrating their triumph."

Jaydene's images have made him realize that the final moments of birth can be the most emotionally intense moments of a person's life. "No matter how exhausted a partner is, as soon as the baby arrives and is in their arms, they are re-energized. Those first few moments holding a new life are euphoric, miraculous, magical—and surreal. No matter what they just watched their partner endure to birth their child, all the pain is forgotten, and they feel bliss."

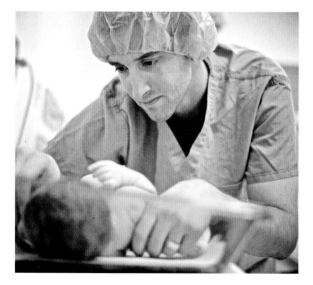

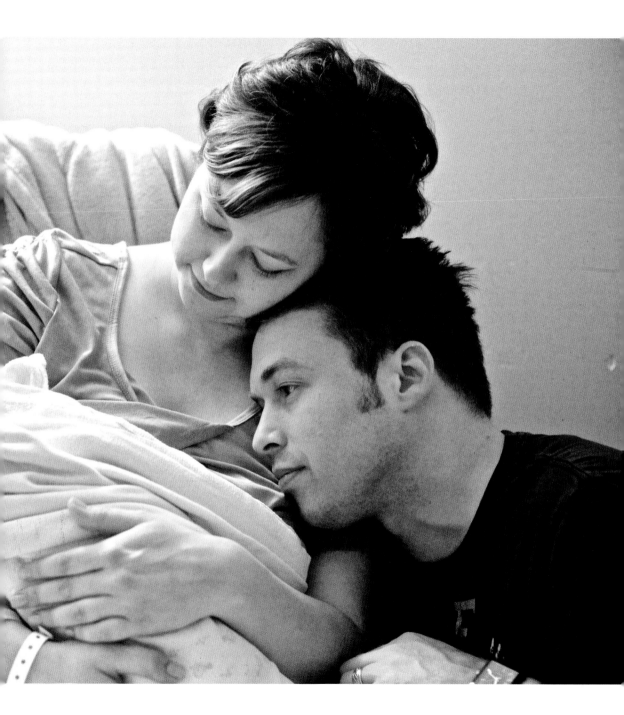

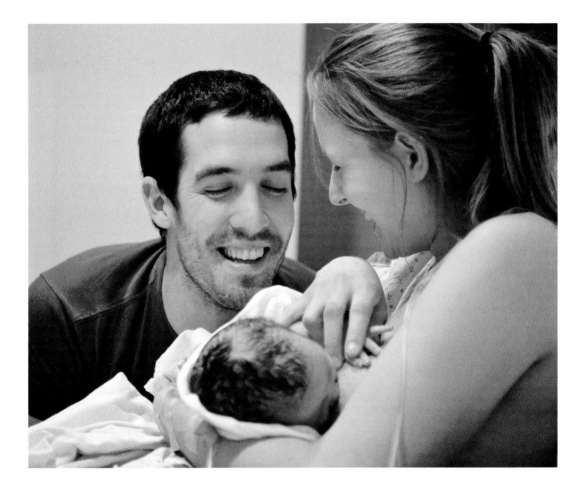

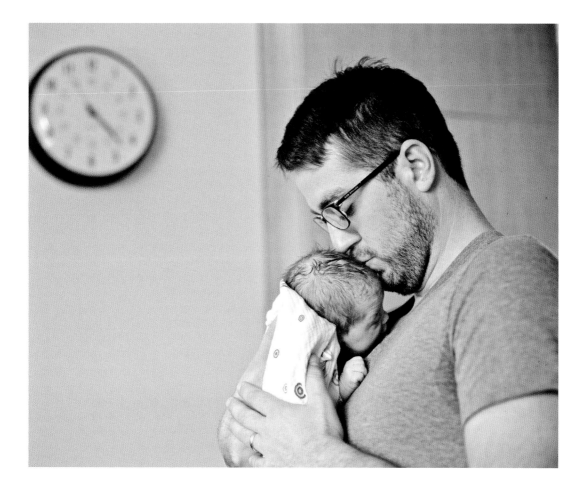

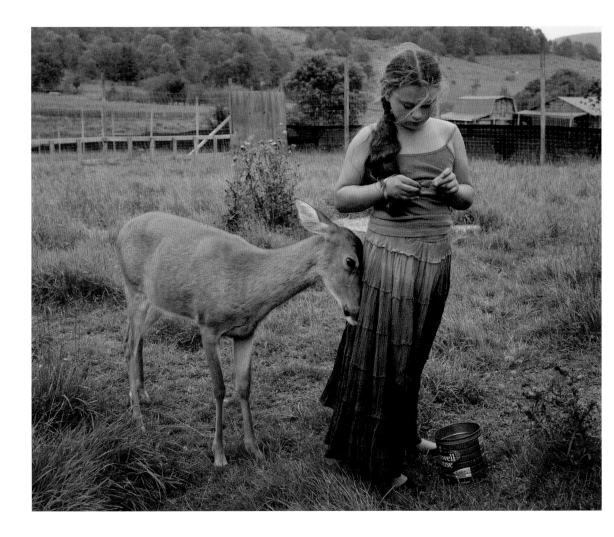

ANIMALS

〜〜〜〜 LIKE 〜〜〜〜

siblings

〜〜〜

ROBIN SCHWARTZ

Amelia Forman didn't have a typical childhood. She grew up in Hoboken, New Jersey, alongside all types of animals, playing with them like they were her own siblings. Amelia's mother, Robin Schwartz, has been a photographer for thirty years, taking photos of various animals, such as dogs and primates. She has also been documenting her daughter's unbreakable bond with animals in an ongoing thirteen-year photo series titled *Amelia and the Animals*.

The images follow Amelia as she interacts with animals that are not usually pets, like chimpanzees and kangaroos. Robin's experience as a photographer opened up many opportunities for her daughter to meet these exotic animals. Amelia can be seen gently stroking the head of a camel or being playfully lifted off the ground by an elephant's trunk. Each image shows the remarkable bond between a child and an animal. "My daughter is more than a sweet and beautiful model," Robin says. "Amelia is smart, tough, and brave enough to calmly cajole animals. Amelia and the animals connect with each other; no animals have been Photoshopped in. She has enormous fortitude and ingenuity, and relates to each individual animal with kindness and respect."

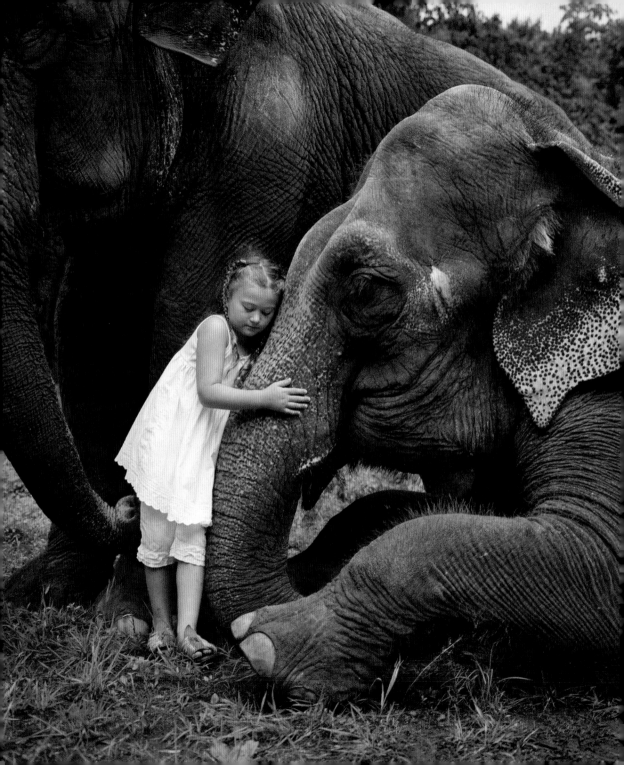

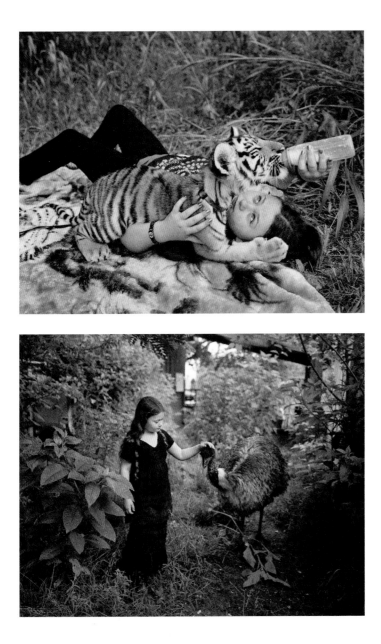

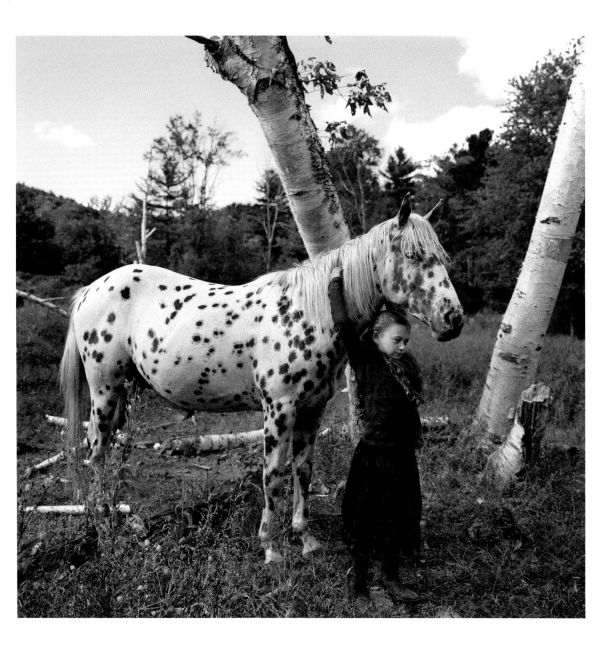

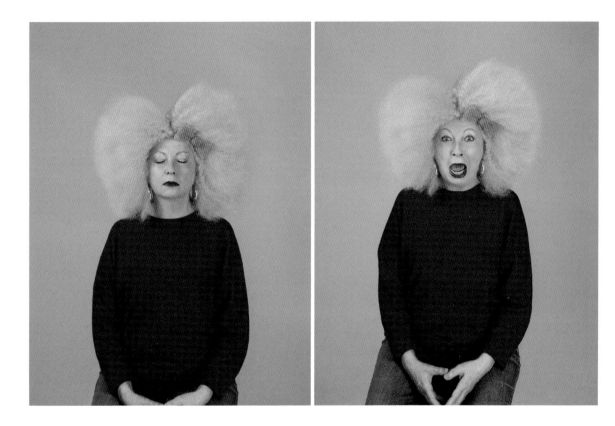

CANCER PATIENTS' CRAZY makeovers

VINCENT DIXON

"You know what I miss the most? Being carefree." This phrase from someone stricken with cancer inspired the *If Only for a Second* photo project by the Mimi Foundation, a charitable organization in Belgium that supports more than fifteen thousand cancer patients each year as they undergo treatment, and Leo Burnett Paris, the French branch of a global advertising company.

For the project, which also served as a cancer-awareness campaign, twenty cancer patients were asked to participate in a unique makeover experience. Invited into a studio with a two-way mirror, the subjects closed their eyes as their hair and makeup were completely redone. The subjects were fitted with elaborate wigs by well-known hair stylist Gregory Kaouat, which ranged from mullets to beehives. On the other side of the mirror, professional photographer Vincent Dixon snapped the exact moment when the person opened his or her eyes to see the makeover.

Vincent's friend Xavier Beauregard, the creative director at Leo Burnett Paris, had shared the project idea with him. "His concept was built on a common theme that many of the patients had expressed, which was that, since the day they were diagnosed, it was nearly impossible for them to be carefree. Xavier wanted to find a way to give them that, even if only for a second.

"I wanted to work on this project, no matter what it took. I loved the concept. It was such a positive way to discuss a subject that is often difficult to deal with."

More than sixteen million people watched a video showing the cancer patients' reactions to their makeovers. Proceeds from the sale of an art book featuring the patients' photographs were donated to the Mimi Foundation.

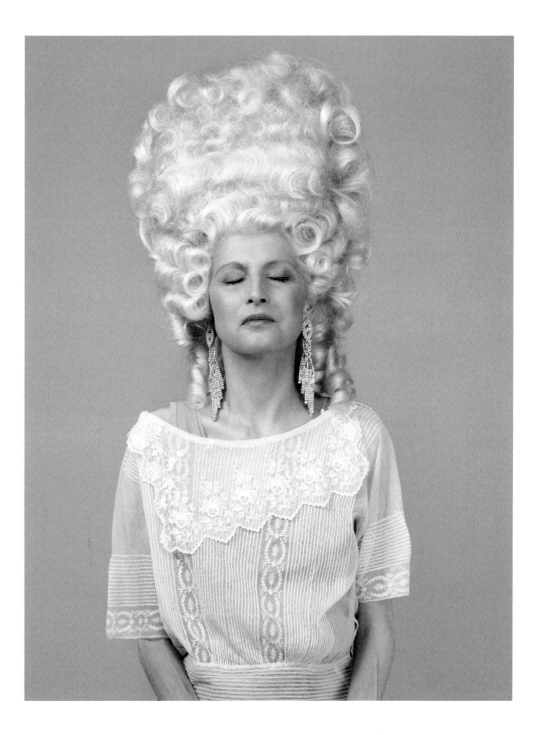

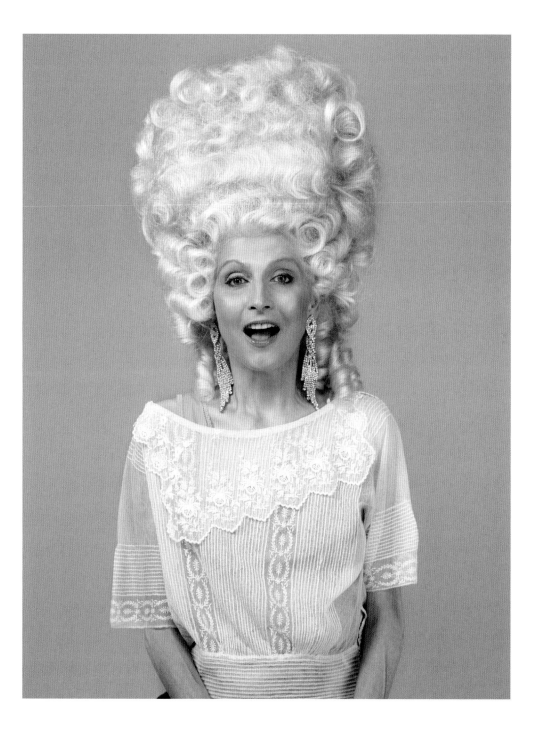

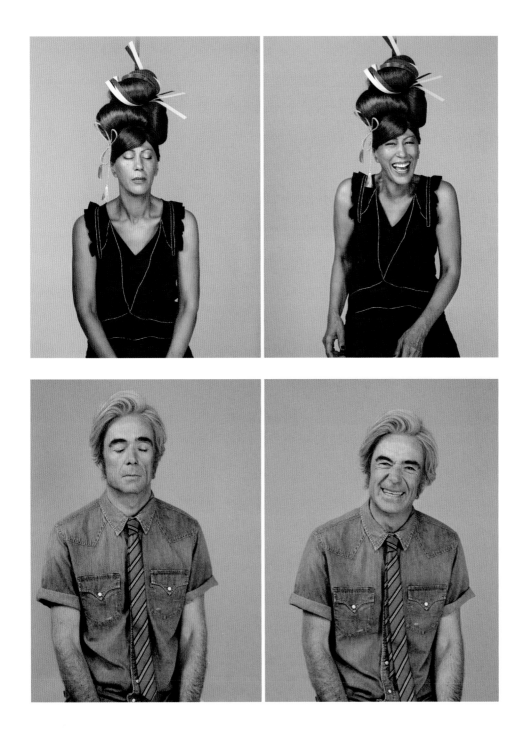

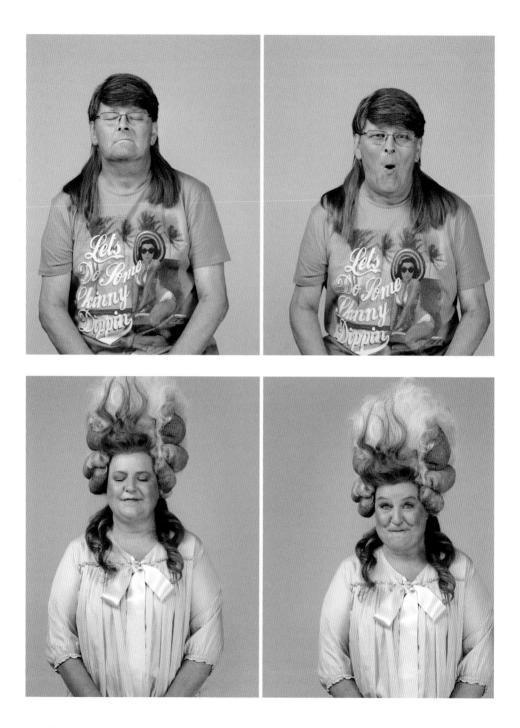

creatively capturing
KIDS

JASON LEE

Wedding photographer Jason Lee is accustomed to capturing some of the most important moments in a couple's life. The real magic happens, however, when he turns the camera onto his daughters, Kristen and Kayla.

In 2006, Jason's mother was diagnosed with cancer. At the time, Jason's young daughters were constantly sick with colds and coughs; consequently, he couldn't always bring them to visit their grandmother. So he started a photo blog as a way to keep his mom up to date and in good spirits.

Jason has inspired millions with his story of love and compassion. Not only do his photos show a son's sweetness toward his ailing mother, they let us experience a real relationship between a father and his two daughters. Sure, his children are adorably cute, but that's not what makes his photos so heart-warming. It's when he puts his own spin on their everyday moments that we're able to see a father's love and pride shine through.

When asked what he's learned about being a father while shooting his photos, he says, "Patience, definitely patience. I also learned how to make my girls laugh and giggle by acting like a complete clown. Finally, I learned that spending quality time with the girls during these shoots has been more reward-ing than anything in the world."

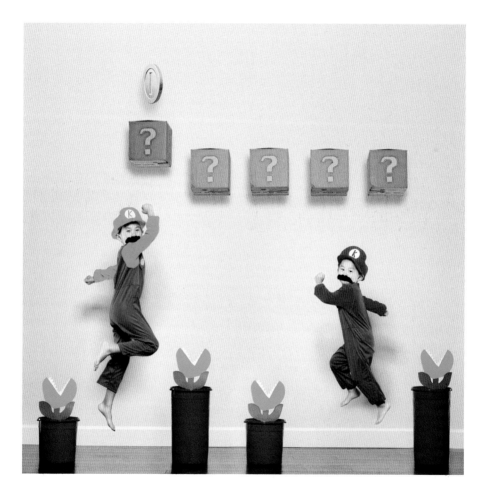

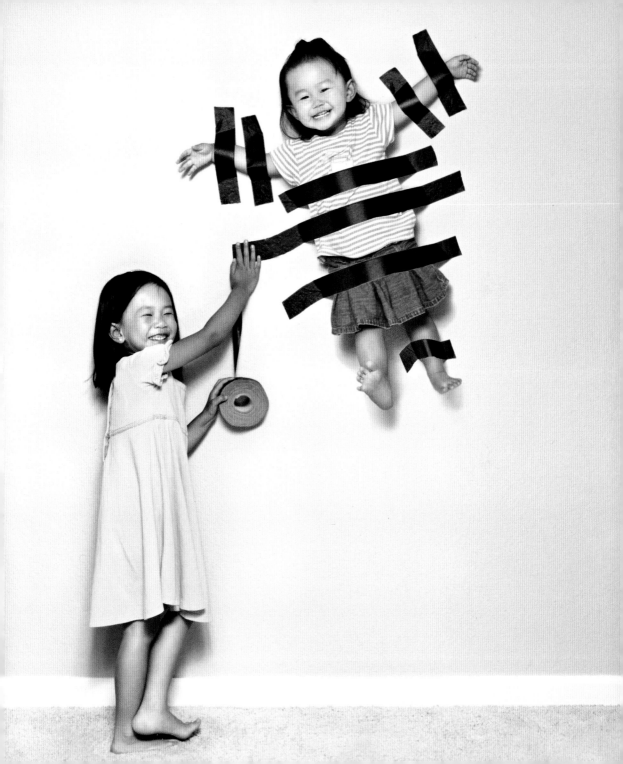

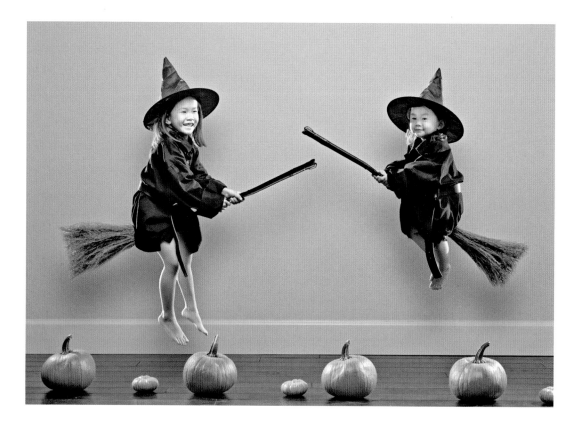

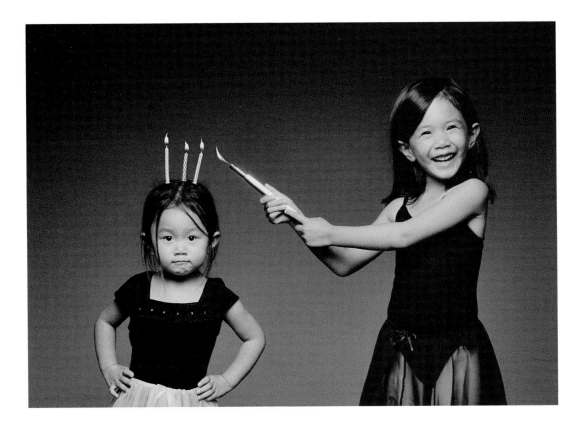

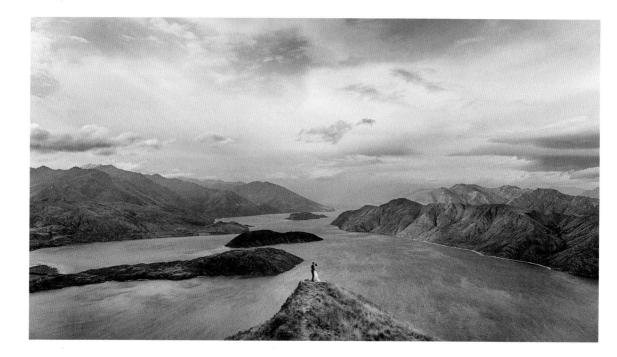

AN UNFORGETTABLE
wedding gift

ERIC RONALD

Photographer Eric Ronald captured photos of a lifetime for New Zealand couple Belinda and Campbell Stewart. As a surprise for her soon-to-be husband, Belinda arranged for two helicopters to pick them up after the ceremony and soar over a nearby lake, landing on top of a mountain. "I'd always dreamed of going up in a helicopter to get our wedding photos—because the Wanaka region is so stunning, and I knew the photos would be amazing," Belinda says.

Despite the wind, the choppers appeared on the horizon. The groom remembers the dramatic moment vividly. "I actually thought someone had injured themselves and the chopper had arrived to fly them out. I then saw the second chopper, and that's when it clicked that Belinda must have organized the helicopters to take us away for photos. I was so surprised. I couldn't get the smile off my face."

Soaring over Lake Wanaka was a surreal experience. "Literally, we dropped on a spot only just big enough for us to land," recalls Eric, the photographer. "We jumped out and were greeted by one pretty amazing view. It was like being inside an oil painting.

"Belinda and Campbell shared their first moment alone as a married couple, standing on top of a mountain above their hometown of Wanaka, holding each other, looking into each other's eyes and surrounded by the most amazing view I have ever seen."

The groom fondly remembers the magical moment, "Apart from it being a tad windy, it was beautiful—because I'd just married the woman of my dreams in my favorite place with my favorite people around."

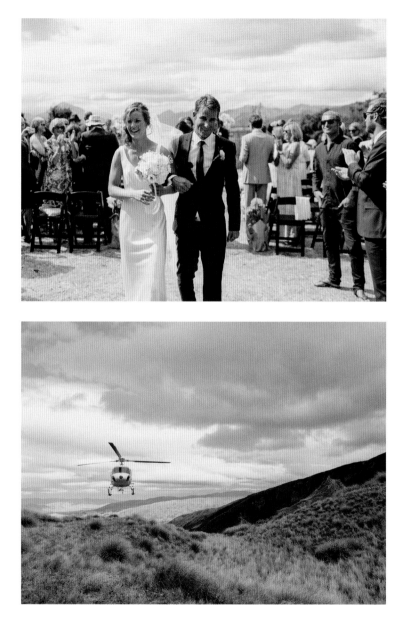

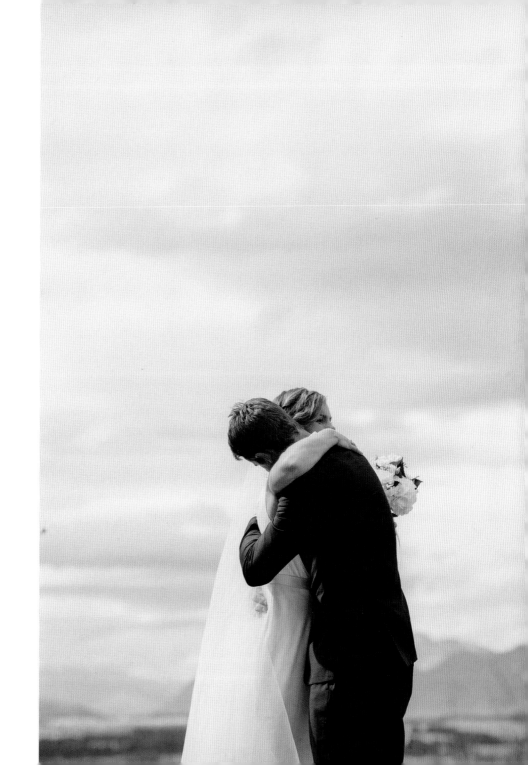

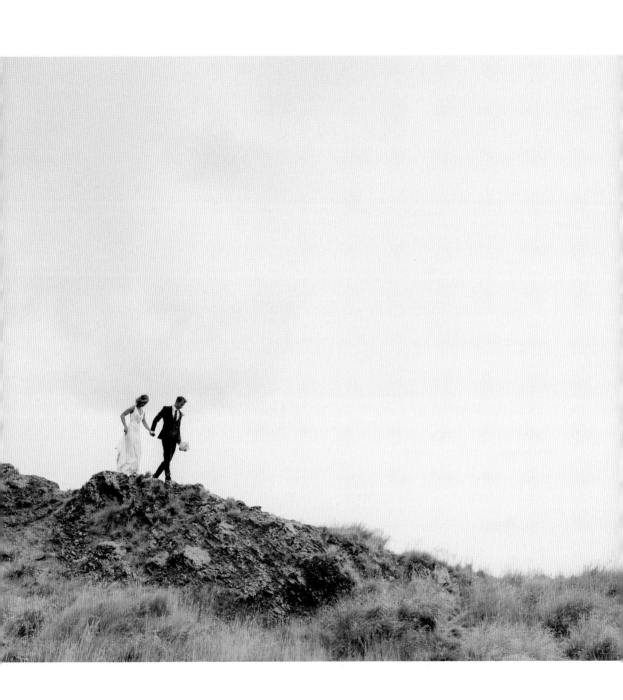

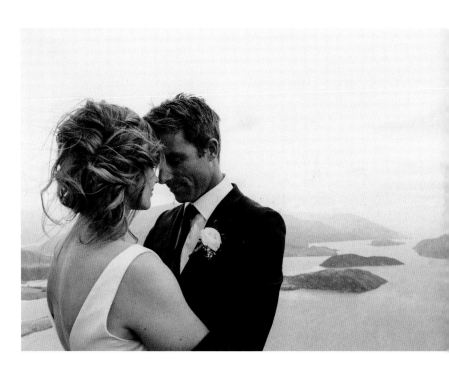

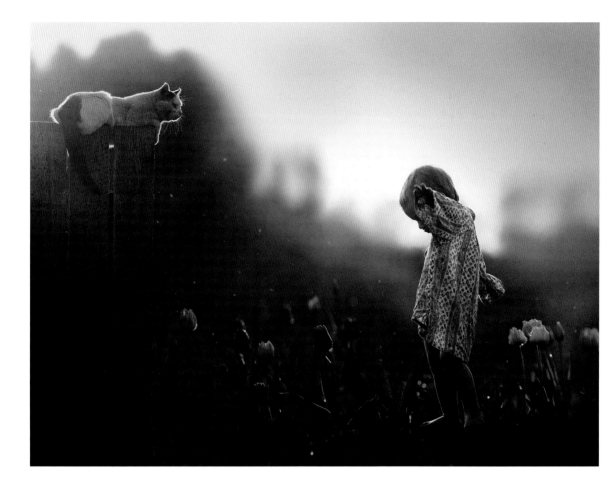

BOYS
AND FARM ANIMALS

ELENA SHUMILOVA

From her base in the Russian town of Andreapol, Elena Shumilova takes images of her sons, Yaroslav, six, and Vanya, three, and their furry, feathered, and fluffy companions in the countryside, transporting viewers into a fairy-tale world. Elena's images capture her two young ones playing with various animals on their farm, including ducklings, bunnies, cats, and dogs. Even though they like to help all the animals while working on the farm, they have a special relationship with their cats and their big dog, Misha.

Elena got her start as a photographer after an epiphany. "I'd been an architect for about ten years, but one moment, when I was thirty, I realized that design and architecture didn't inspire me anymore, and I started to find myself in photography."

Elena is known for her beautifully lit shots, using only natural light, and never a tripod. Whether the photograph is taken out on a dirt road, in a wintry forest, a lush field, or just indoors, Elena catches the light perfectly. "When shooting, I prefer to use natural light—both inside and outside," she says. "I love all sorts of light conditions—street lights, candle light, fog, smoke, rain, and snow—everything that gives visual and emotional depth to the image."

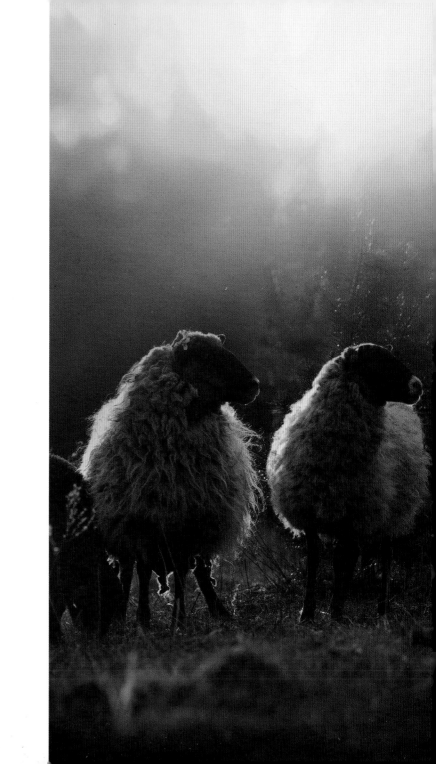

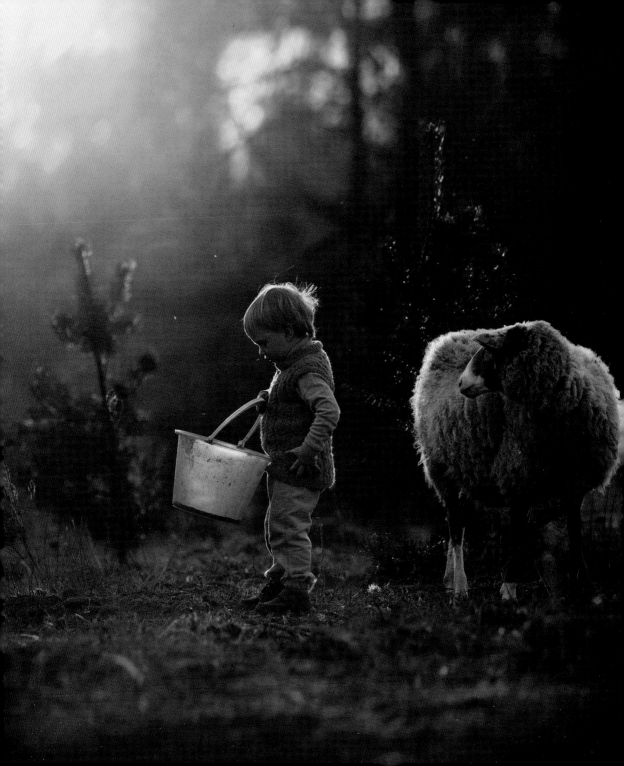

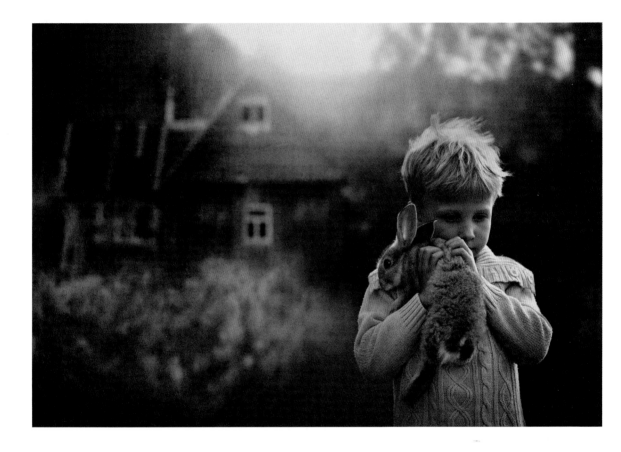

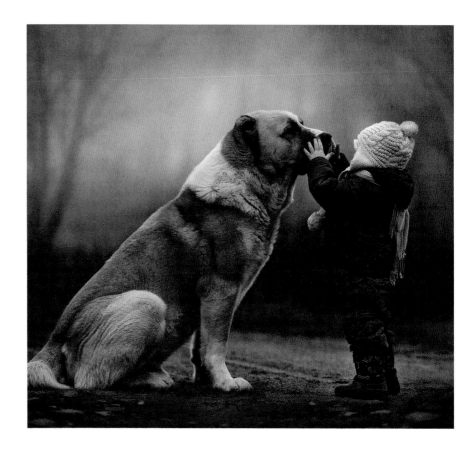

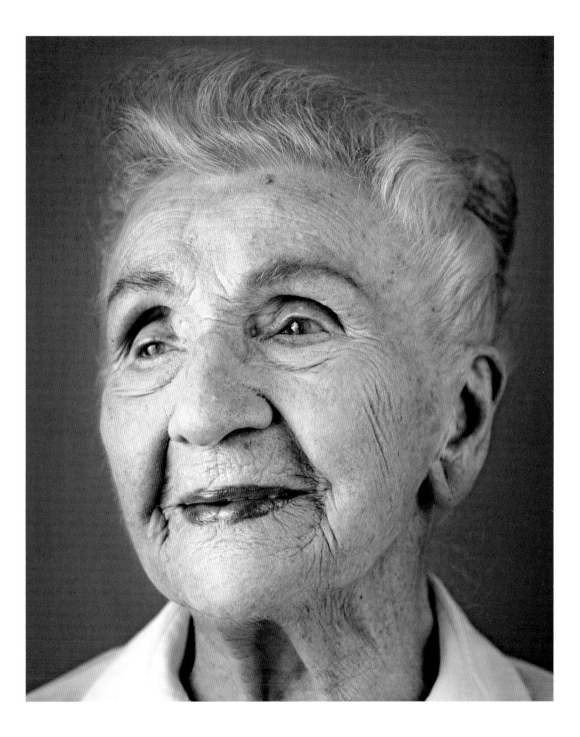

Happy
at
ONE HUNDRED

KARSTEN THORMAEHLEN

In 2006, German photographer Karsten Thormaehlen began the *Jahrhundert mensch* (centenarians) project, titled in English *Happy at Hundred*, consisting of portraits of people who had lived a century or more.

The idea came about when he began working in nursing homes. "I felt sorry for these old people, just sitting there, and waiting to die. It's not what you work all your life for, to have an end like this," he says. He experienced a turning point one day when he saw a newspaper photograph of a man who was celebrating his hundredth birthday, happily holding a glass of wine. "I thought, 'OK, there are other people who have lived a century and are happy still living at home,'" he explains.

Karsten began looking into whether any photographers or artists had taken up the subject of centenarians, and came up with virtually nothing. He found that publishers actually shied away from such subjects, assuming that those kinds of books wouldn't sell. But after holding successful photo exhibitions in a few European countries, he says that "something changed." Publisher Kehrer Verlag then offered to market his book, which he called *Happy at Hundred*.

"A lot of the centenarians have experienced war, or the death of someone close to them. There's a commonality in all the centenarians I've met. Nobody is aggressive. They are friendly, and have wisdom. Some of them have a particular kind of sense of humor. It's really fun to work with them," Karsten says. "On the surface, you only see wrinkles, but in the eyes and in the whole gesture, there's beauty. That beauty comes from the inside and radiates outside."

79

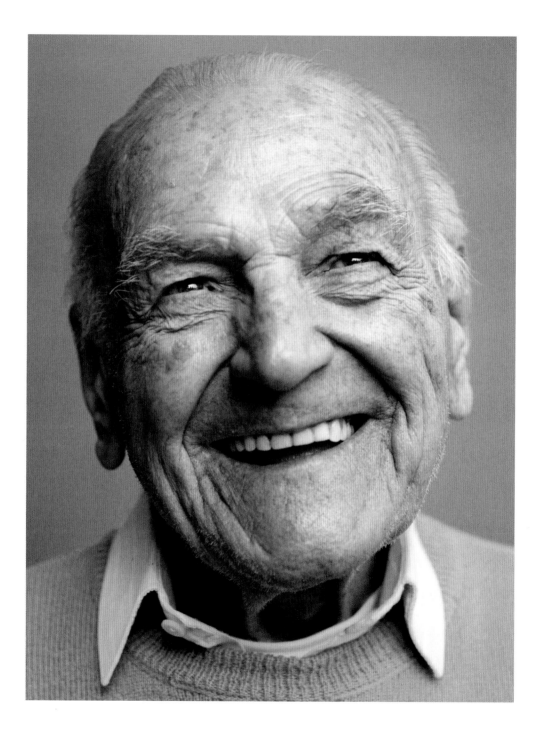

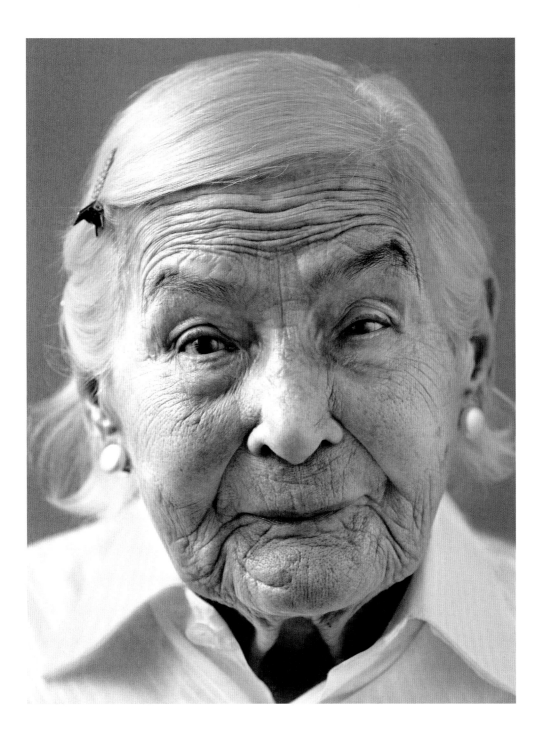

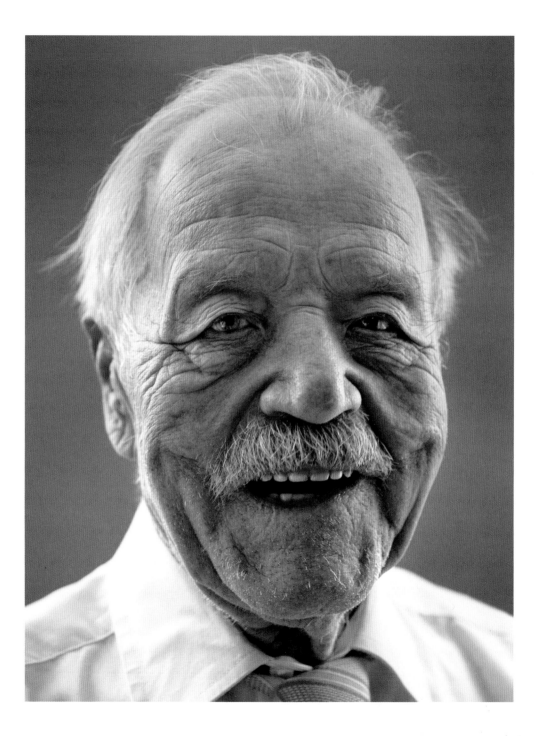

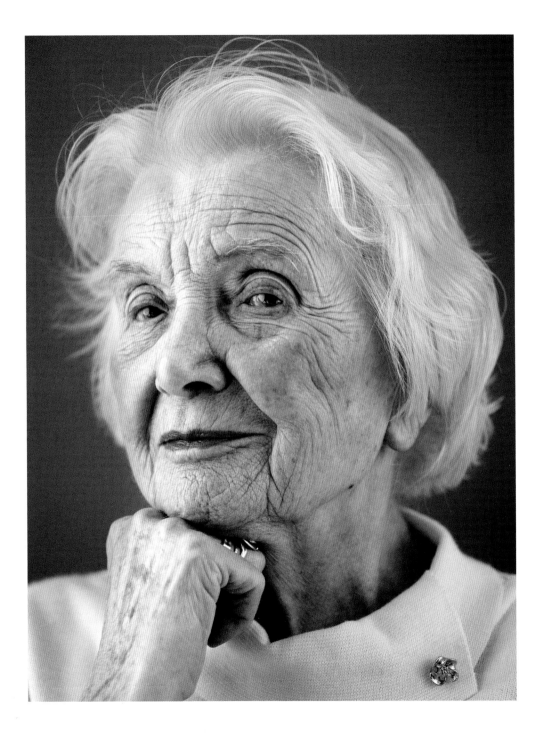

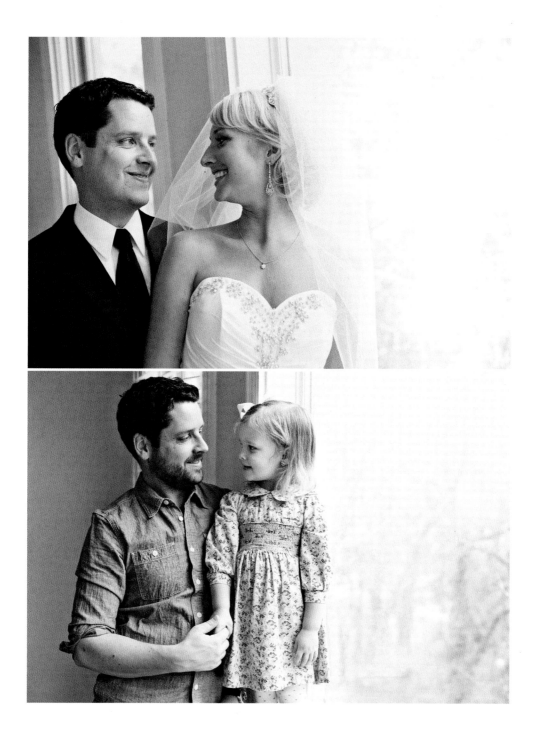

RE-CREATED
WEDDING
photos

MELANIE PACE

Father and daughter Ben and Olivia Nunery lost Olivia's mother, Ali, to a rare form of lung cancer when Olivia was just a year old. After two years of being on a "roller coaster of emotions," Ben decided to move out of the Cincinnati home that they had lived in with Ali. Before they left, Ben asked his sister-in-law, professional photographer Melanie Pace, to take photos of him and his then three-year-old daughter in the home to serve as lasting memories of their lives there.

Ben and Ali had closed on their house the day before their wedding, and they had taken their wedding photos in their new, empty house. Four years later, Ben said one last good-bye to the house, which was once again empty, with Olivia, as they re-created versions of the original wedding photos.

Though Ben says that he did the shoot just for himself and his daughter, the heartbreaking side-by-side photos were shared all over the Internet by viewers who appreciated the vulnerability in each shot. "Many people have asked me how I felt while doing that photo session," Ben says. "What I want them to know is that this isn't a story about grief and loss and hurt. Yes, I've gone through those emotions and still do, but that's not what I want people to see in these photos. This is a story about love."

"I hope others are able to move forward gracefully when given terminal news or have already lost someone," Melanie says. "It's incredibly hard to see anything but one day at a time when you are in the thick of it, but seeing that people can still be happy after devastation gives others hope. I hope others also know the deceased are still fully alive so long as you talk of them often and love them like they never left."

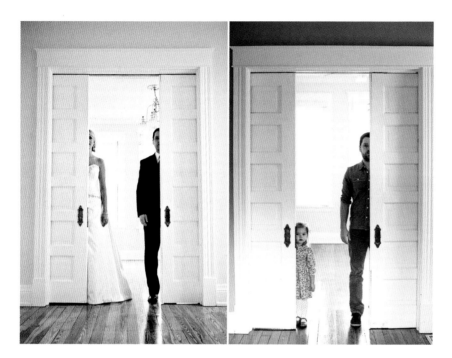

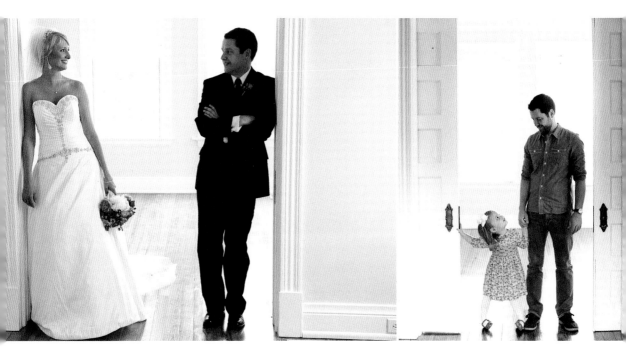

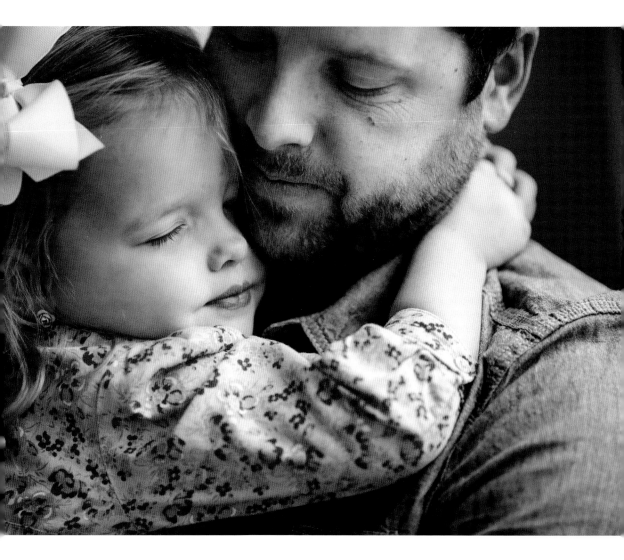

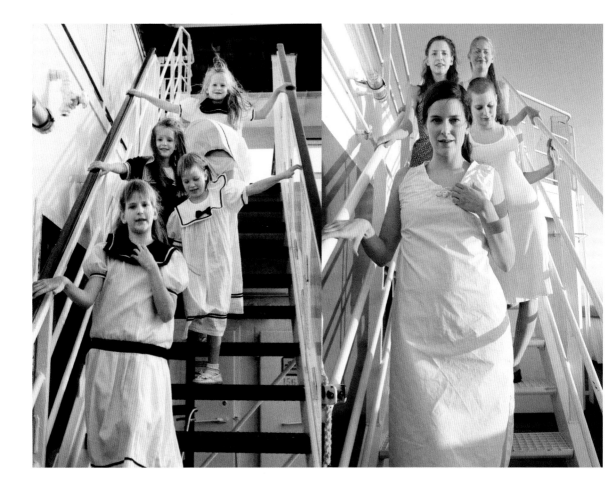

CHILDHOOD PHOTOS
RE-CREATED

WILMA HURSKAINEN

Helsinki-based Wilma Hurskainen asked her three younger sisters to participate in an ambitious project—to re-create thirty old photographs her father took of them when they were young. She wanted each new photograph to look as similar as possible to the original, so the backgrounds, composition, body positions, and facial expressions had to be exactly the same.

The project proved to be a difficult task, especially since the sisters lived in different countries. Re-creating the images perfectly was also a logistical challenge. "It was sometimes a little hard finding the places of the original photos, finding the proper clothing, and dealing with the emotions that emerged because of the process of digging up the past," Wilma says. From 2004 to 2006, the sisters would travel to Eastern Finland or Sweden to take the photos. Though their parents still live in the same house where the sisters grew up, the women had to travel to other destinations to re-create many of the photos.

The result is an intriguing side-by-side comparison of the past and the present—a striking portrayal of time as told through the physical metamorphosis of four young women. "The general feeling in the series is very light and happy, so I sometimes forget that my initial feeling when starting to make the images was quite sad," Wilma explains. "I thought the images would speak of nostalgia, letting go, losing moments, and even people, in time. There are only a few images that actually seem to bear this sadness."

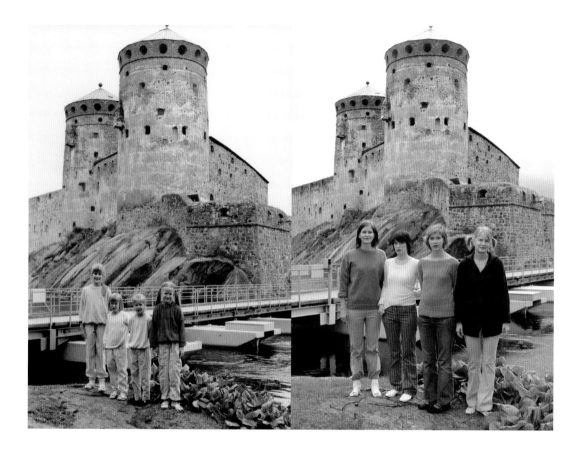

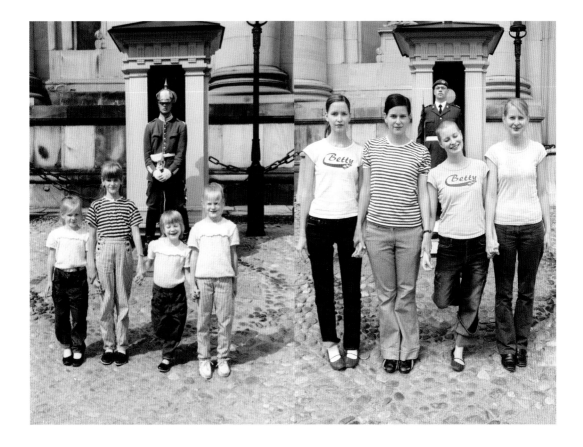

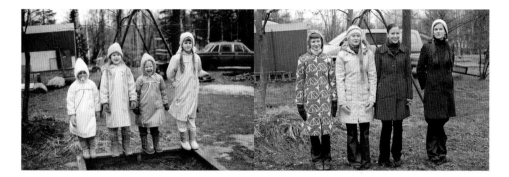

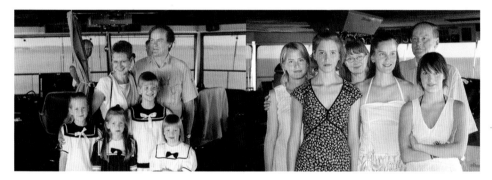

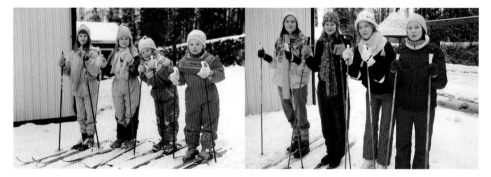

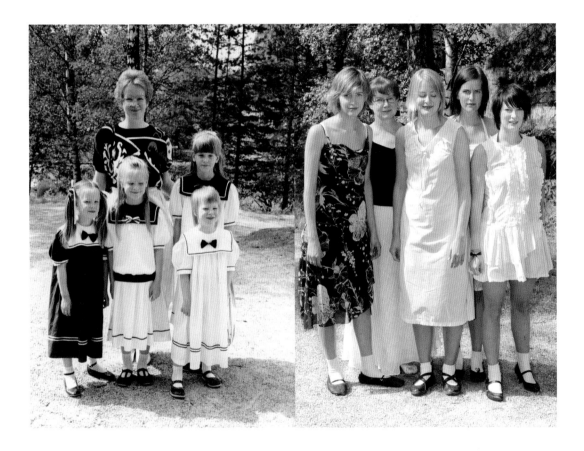

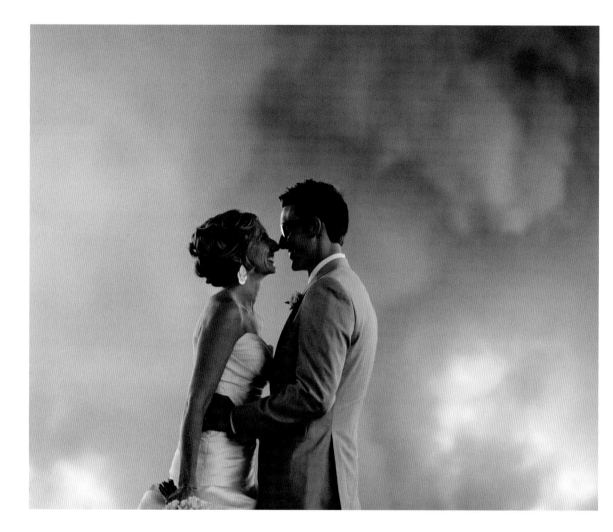

WILDFIRE
wedding

JOSH NEWTON

One can only wish to have wedding photos as dramatic as these. A seemingly ordinary wedding day turned extraordinary for April Hartley and Michael Wolber. The couple was preparing to get married at the Rock Springs Ranch in Bend, Oregon, when the Two Bulls wildfire suddenly swept the nearby Oregon countryside.

When photographer Josh Newton first arrived at the wedding venue, nothing seemed amiss, but as the bridal party got ready, Josh noticed that something was very wrong, as smoke filled the sky. Though no one was in any real danger as the fire raged six miles away, local firefighters arrived at the ceremony moments before the bride was supposed to walk down the aisle, and told everyone they had to evacuate. The father of the bride calmed the guests and announced that everyone had to leave the scene, but the wedding coordinator talked the firemen into letting the couple get married if they agreed to shorten the ceremony. "Man, was it nerve-racking!" Josh says. "Everyone was on the edge of their seats." The couple was married in less than twenty minutes.

After the ceremony, Josh and the newlyweds were able to sneak in a few shots as the wildfire roared in the background, and eventually the wedding photos went viral. "I had no idea that the wildfire photos would be so incredible, and I had no clue that they would explode all over the world," Josh says. "I doubt I'll ever be able to top the dramatic aspect of the photos, as it was a chance of a lifetime."

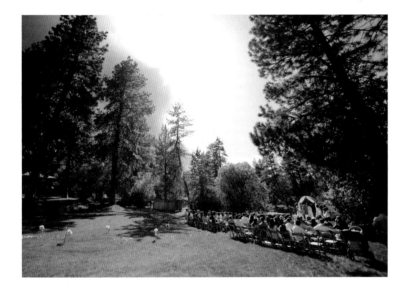

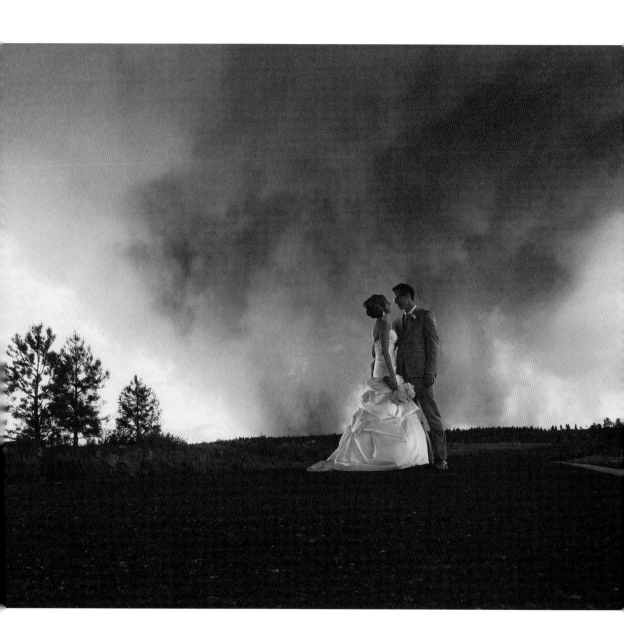

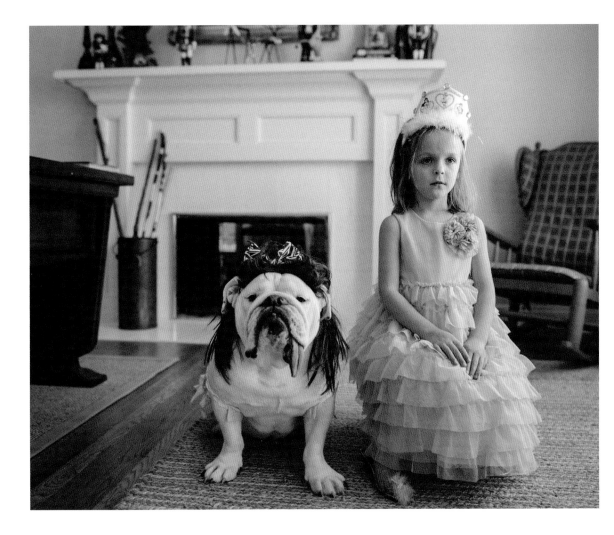

the
BEST BUD
BULLDOG

REBECCA LEIMBACH

After suffering through years of infertility, Michigan-based photographer Rebecca Leimbach and her husband welcomed their beautiful daughter, Harper. Soon after she was born, they tried to have more children, but even fertility treatments proved unsuccessful. After feeling an immense sense of sadness that Harper would never have a sibling, Rebecca was surprised to discover that her daughter already had a wonderful playmate living in their house all along—their loyal English Bulldog, Lola.

"One day Harper came out of the playroom with Lola dressed as a princess, and I realized Harper has a playmate, the best kind in fact, one who doesn't argue over being dressed up," the forty-year-old mother says.

"They have a funny bond. Harper loves Lola immensely, except when Lola eats her toys, which happens quite often. Lola is very protective of Harper; she is always in Harper's business. Whatever Harper is doing, Lola must investigate."

Rebecca hoped to capture Lola's connection to Harper in this photo series. When Harper looks back at her childhood through these images, she will remember 'my first best friend,' Lola. I hope people take away from the images that, sometimes without us even realizing it, dogs fill an empty space in our hearts."

Rebecca couldn't believe the response she got after the photographs went viral online. "It was completely incredible. I didn't realize that so many people would relate to us. I shared my struggle with infertility, of Lola filling the void of not being able to have another child. People were so kind, and shared their own stories of struggling with infertility. I realized what great company I was in."

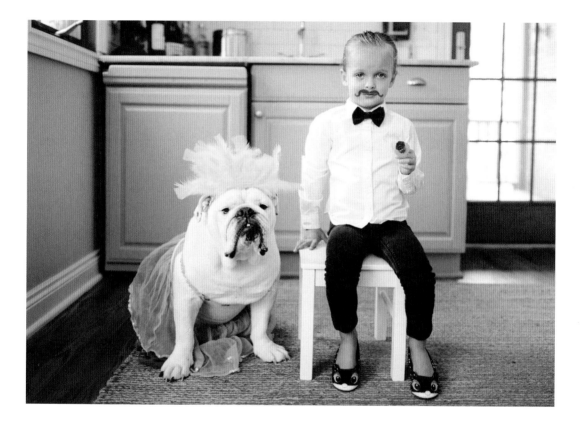

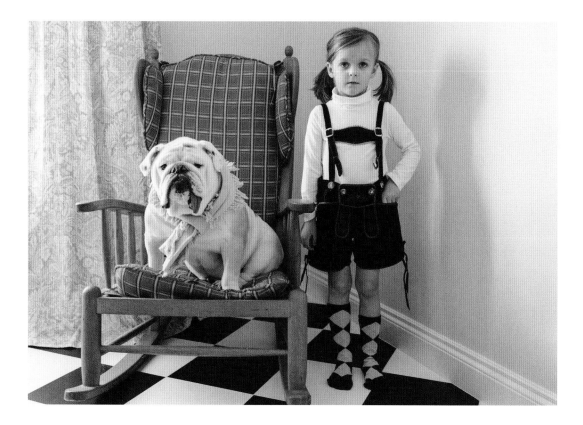

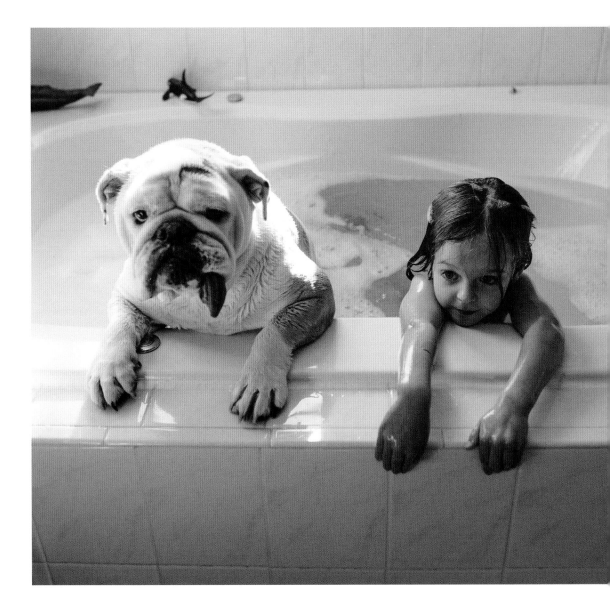

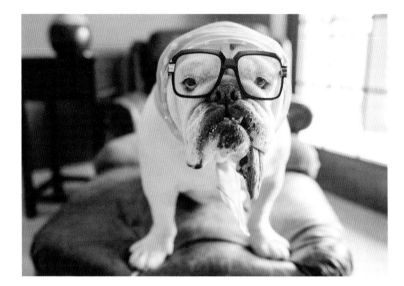

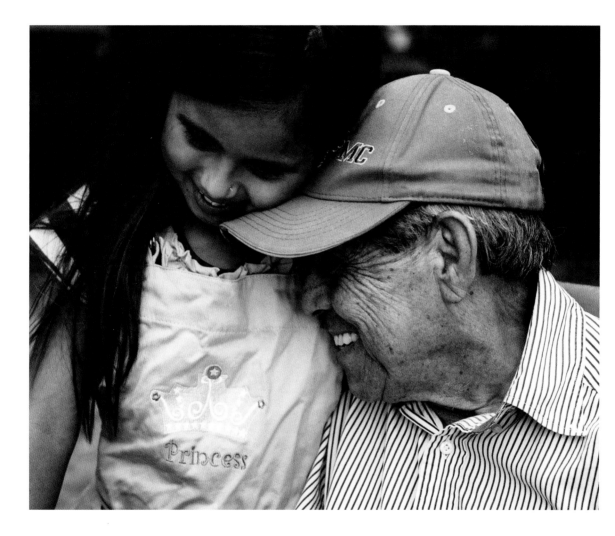

Life
WITH
GRANDPA PITO

GINGER UNZUETA

Life with Pito is a moving photo series by Florida-based photographer Ginger Unzueta. Back in 2007 while Ginger's husband was deployed in Iraq, he made a satellite phone call to his family back home. It was then that one of his brothers informed him that their father, Pito, had been diagnosed with Alzheimer's. Pito, a Spanish nickname Ginger has affectionately given him, was a retired doctor who had specialized in pediatrics and family practice. He was a loving father and grandfather who had made it his life's mission to help the sick.

Now, Pito's Alzheimer's has progressed to the point where the seventy-nine-year-old does not recognize his wife of forty years, his four sons, or his seven grandchildren. Through the emotional hardship, however, there's always been an unwavering love. Ginger's mother-in-law takes care of Pito with the utmost selflessness. Though Pito does not remember her, the woman whom he courted as a nurse in the hospital where he worked after graduating from medical school, she remains steadfast in her love.

In this series, Ginger shows the everyday moments Pito still shares with his family, "his life at home with his adoring wife, sons, and grandchildren. I wanted to be able to capture moments of him now—not always pretty moments, but his life as it is," Ginger says. "I feel our family needs these memories. These memories are a part of his story, just as much as his childhood memories are."

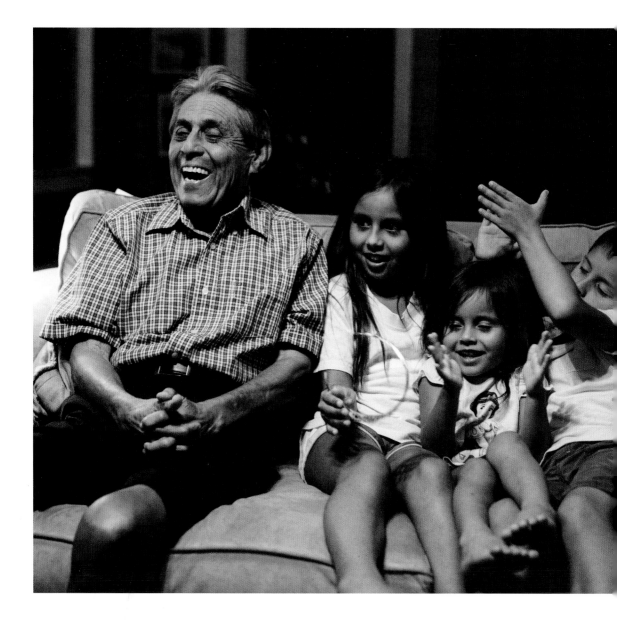

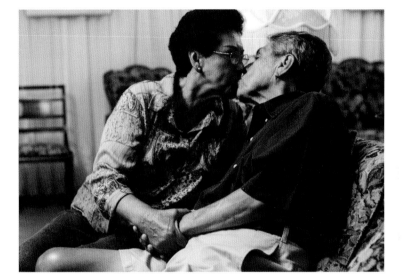

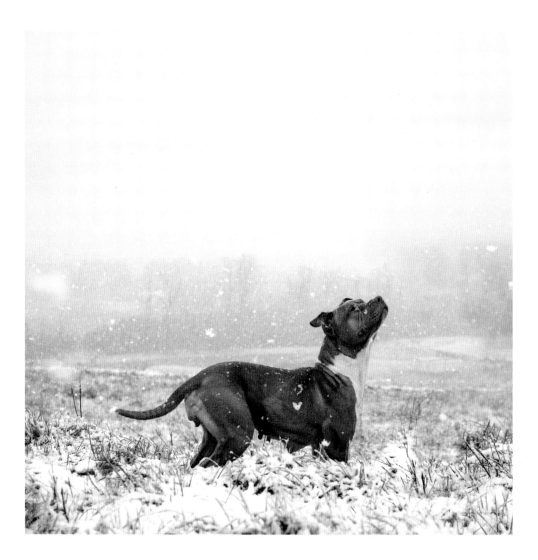

LANDFILL

DOGS

SHANNON JOHNSTONE

For one week in each month, photographer Shannon Johnstone brings a dog from the Wake County Animal Center in Raleigh, North Carolina, to the local landfill to photograph them for her ongoing series *Landfill Dogs*. Shannon hopes the beautifully composed portraits will give the animals a chance to live a better life. "These are not just cute pictures of dogs," she says. "My goal is to offer an individual face to the souls that are lost because of animal overpopulation, and give these animals one last chance."

Shannon chose the landfill site as her backdrop to show where the dogs would end up if they didn't find homes, and because it offers an interesting metaphor of hope. "It is a place of trash that has been transformed into a place of beauty," Shannon says. "I hope the viewer also sees the beauty in these homeless, unloved creatures."

The photo series went viral starting in late 2013, about a year after Shannon began the project. Since then, *Landfill Dogs* has been featured on *ABC's World News with Diane Sawyer* and *The Good News with Ellen*, in *Caesar's Way* magazine, and in several national newspapers.

"This project is very close to my heart," Shannon says. "I have six rescue animals, four dogs, and two cats. The only difference between most of the shelter cats and dogs and the ones in my house is that nobody loves shelter animals enough to claim them as their own. This weighs heavy on my heart and inspires me to do what I can."

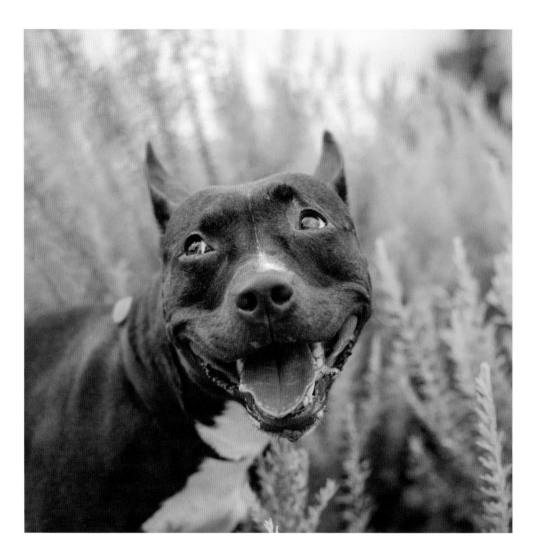

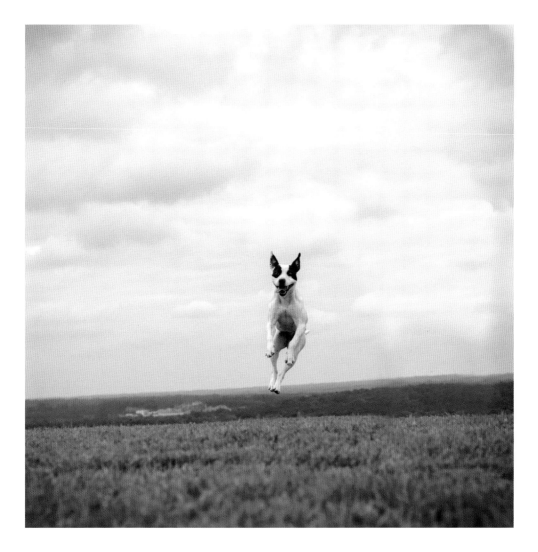

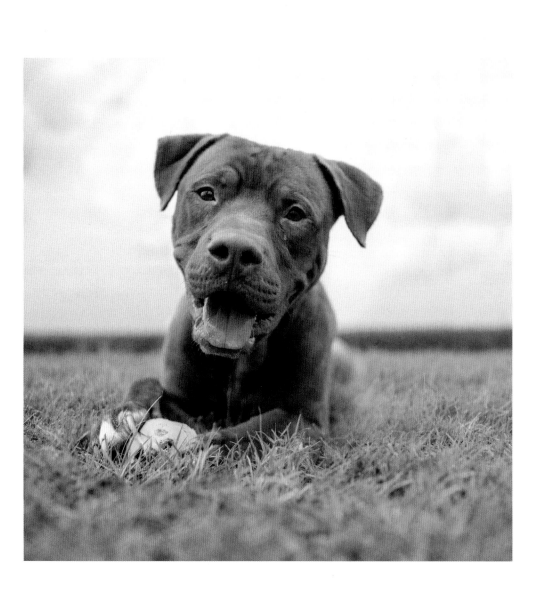

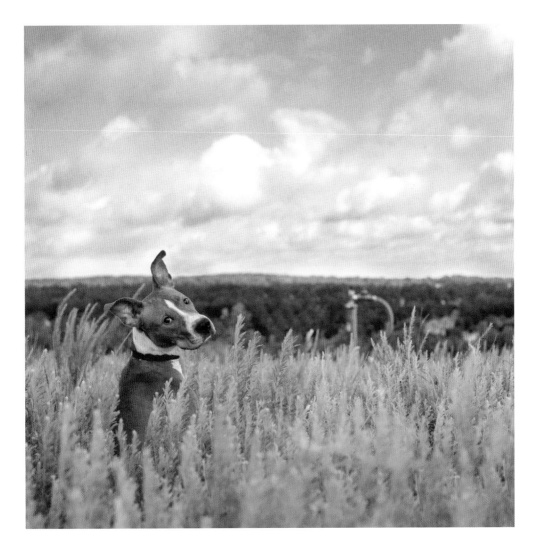

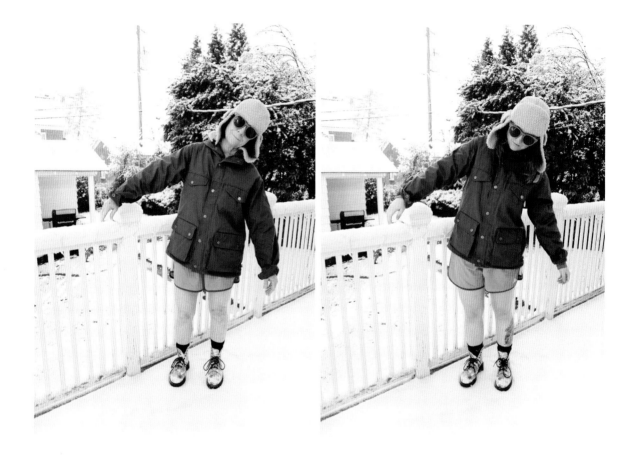

A
LOOK-ALIKE
PROJECT

CARRA SYKES

North Carolina–based artist Carra Sykes shows us the similarities between mothers and daughters in this lighthearted series. The artist photographed herself and her mother, Marti, wearing the same clothing and standing in the exact same positions. The inspiration behind the project came from Carra's uncle, her mother's twin, who always joked about Carra and her mother wearing the same outfits.

Marti was very supportive of her daughter's artistic experiment from the day she began working on the photo series. "She brought the 'bring it on' attitude, and was an awesome model," Carra says of her mother. "I loved watching her get more and more excited as the series continued. I have enjoyed her enthusiasm and energy towards our adventure together."

Carra and her mother have always been close, but working on a series brought the two even closer despite the literal distance between them. "We now live about 1,125 miles apart from each other. I miss her so much, but I'm so thankful we created work together."

As Carra's photographs made their way around the Internet, many people were drawn to the series for its whimsical nature, which was the artist's real intention. "Most of my work comes from a place in my heart that tries to remember what it feels like to be a kid, full of imagination and nothing holding you back."

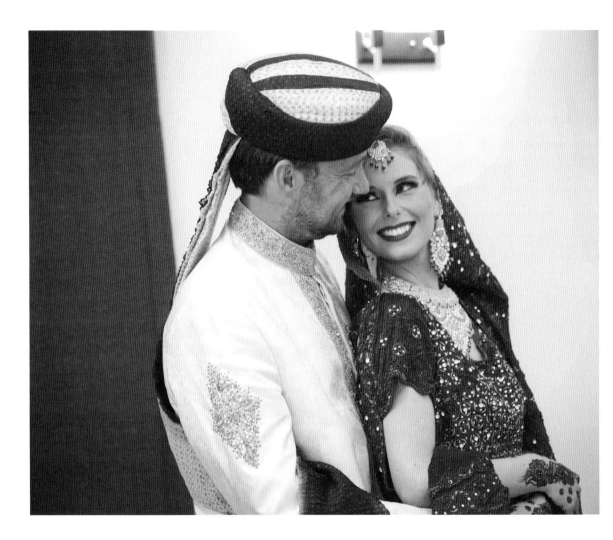

ROUND-the-WORLD WEDDINGS

VARIOUS PHOTOGRAPHERS

Some people say that their wedding day is the best day of their lives. For British couple Lisa Gant and Alex Pelling, it is a day that they continue to live over and over again. After selling all of their assets, the duo embarked on a traveling wedding adventure, seeking to experience a traditional wedding in each country they visit across the globe. So far, they have taken part in more than twenty weddings.

The ongoing journey has allowed Lisa and Alex to explore the world and learn how different cultures celebrate the union of two people within their own set of customs. Lisa and Alex's ultimate goal is to get officially married at their favorite location, once they've completed their matrimonial expedition. Their journey can be tracked through the couple's blog, 2people1life.com, which also includes a map of all the places they have visited.

Lisa and Alex's travels have brought them even closer, further cementing their love. "Our relationship has always been strong, as we were friends for over eight years before finally getting together romantically, which means we have a great bond," the couple says, "but this trip has cemented that bond. We have grown into the people we have always wanted to be, and we have done it together.

"We are together 24/7, and still fall more in love with each passing day. We have become stronger, closer, and more confident in our marriage and our ability to overcome anything that life throws at us."

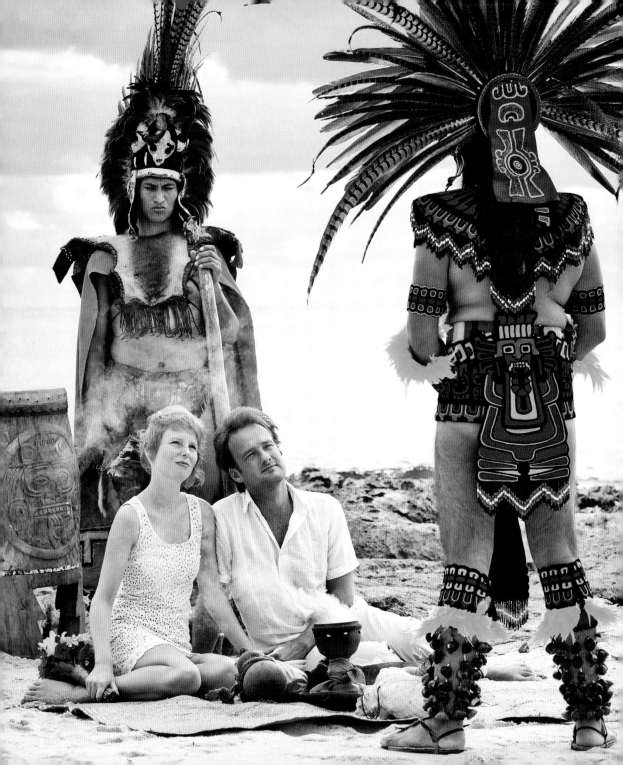

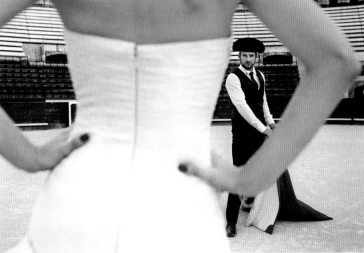

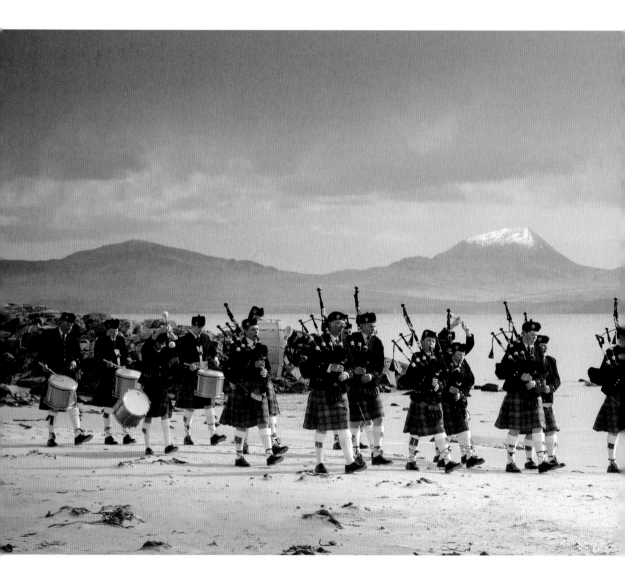

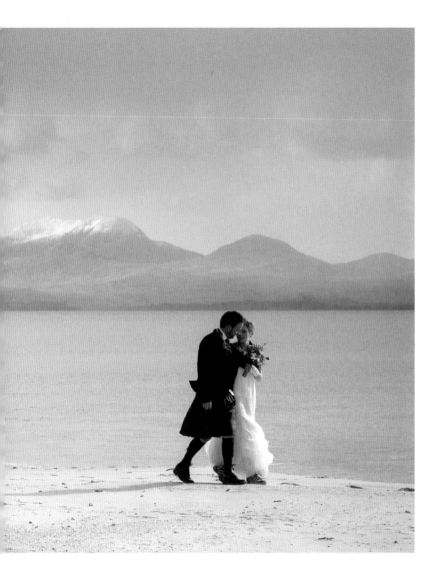

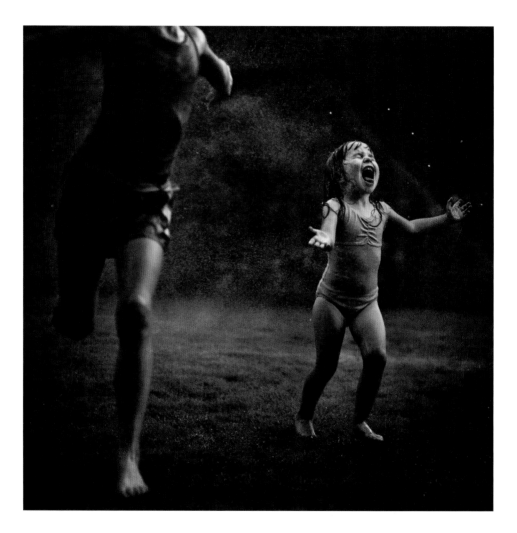

A mother's *Timeless* PHOTOS

KATE T. PARKER

Mother and professional photographer Kate T. Parker invites us to relive the magical moments of our childhood through these photos of her two daughters, Ella and Alice. Taking inspiration from artist Norman Rockwell and his idyllic images of American life, the Atlanta-based photographer captures her two young girls and their friends living their lives with a sense of wide-eyed wonder.

"I want to preserve the fun and joy of their childhood," Kate says. "I want to show them the amazing, the mundane, the terrible, and the great things that they did as children. Childhood is so fleeting and memories are unreliable, but images last.

"Teeth are lost and grow in an instant. What today is so much fun and 'awesome,' tomorrow is boring. I want to be there to photograph the change. I shoot them daily and have done so the last three years. I am so thankful for those images."

Most of Kate's photos of her daughters are post-processed in black and white. "I lean towards black and white for the timeless feel that it lends to my images," she states. "An image that equally makes sense if it were taken today or fifty years ago is always a goal for me. Also, my girls are generally dressed so colorfully and almost always mismatched, usually screaming and going one hundred miles per hour, so black and white allows your eye to focus on what is important: the faces, the expressions, the emotion. This quote from Ted Black really sums it up for me: 'When you photograph people in color, you photograph their clothes. But when you photograph people in black and white, you photograph their souls.'"

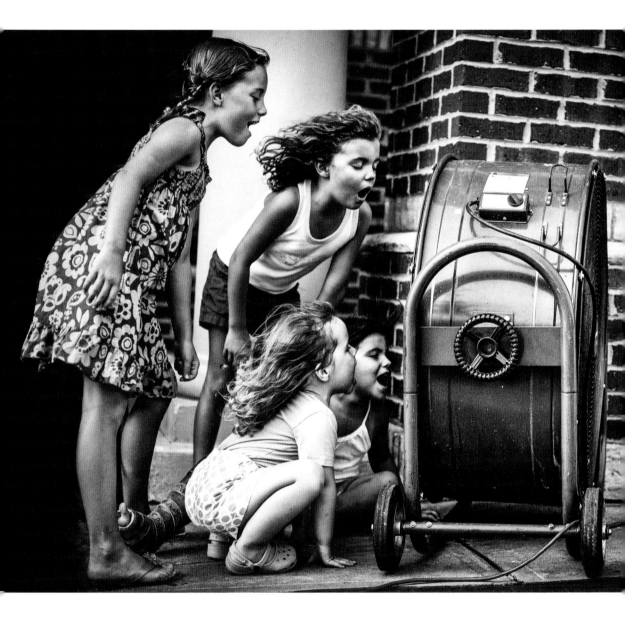

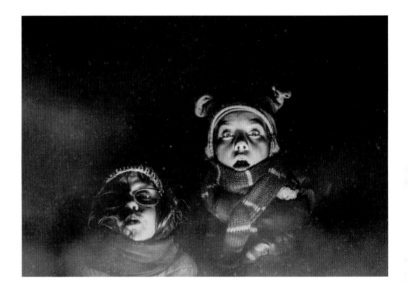

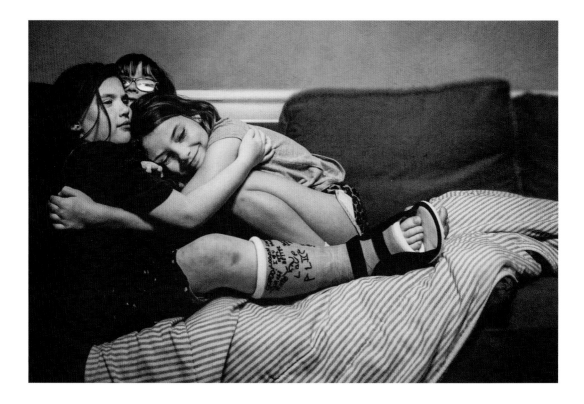

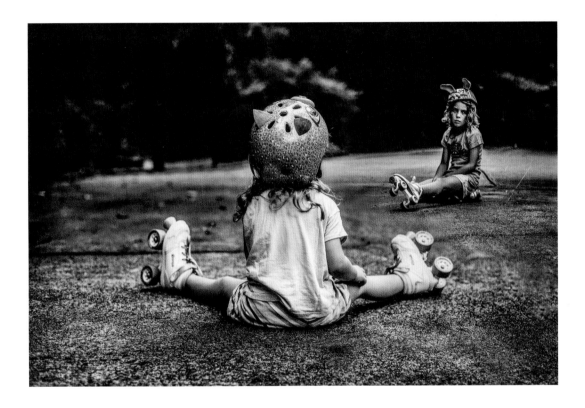

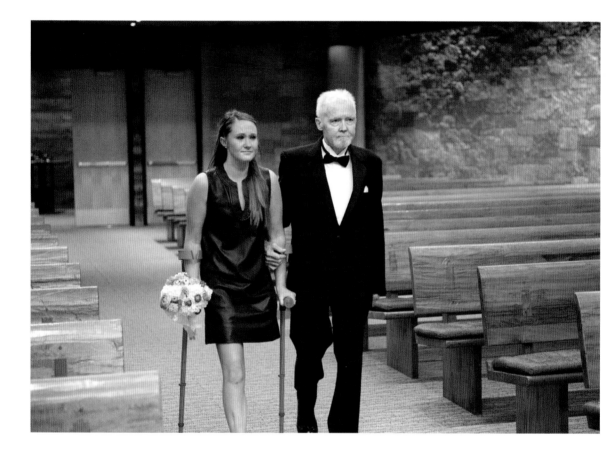

DAD WALKS
UNMARRIED DAUGHTERS
down the aisle

MATT AND JULIE NORINE

One of Fred Evans's lifelong dreams was to walk his daughters, Gracie and Kate, down the aisle on their wedding days. While recovering from a double lung transplant, the sixty-two-year-old father of four was diagnosed with cancer and realized that he had just a few months to live. But despite his illness, Fred was unwavering in his commitment, and the determined dad decided to surprise both of his daughters with a wedding ceremony, despite the lack of grooms.

After hearing about Fred's story, Fotolanthropy, a nonprofit organization dedicated to sharing inspiring stories, reached out to Matt and Julie Norine, wedding photographers at Fotocrew, to help make Fred's dream a reality. The Norines snapped photos of Fred as he astonished Gracie and Kate when they arrived for their surprise ceremony.

The ailing father, donning a tuxedo, then walked his girls down the aisle and gave them each a warm embrace. He gave them a bouquet and told them that he wanted to give them his blessing, in case he wasn't around on their wedding day.

Fred then surprised his wife with her very own special bouquet, and then walked her down the aisle to renew their vows to one another.

"We could actually feel Fred's love for his family," Matt and Julie recall. "We could tell he was a man of great character, and incredibly brave to do what he did that day. You would think it would be an overwhelmingly sad atmosphere, but it really wasn't. It was really just a special, priceless moment for the entire family, especially the two girls. It was a blessing to watch an act of love like that."

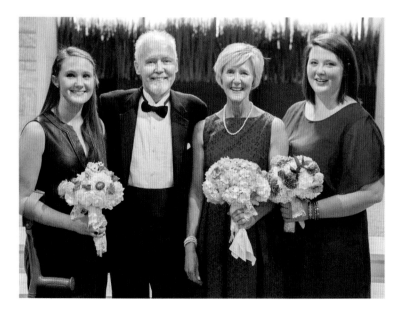

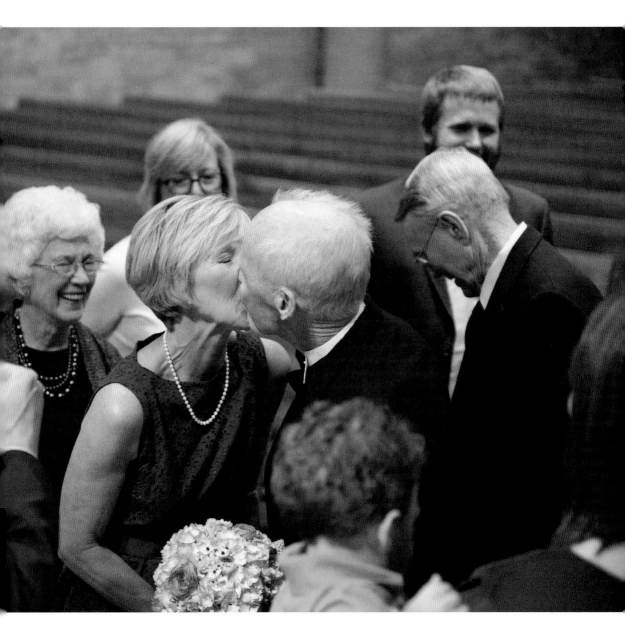

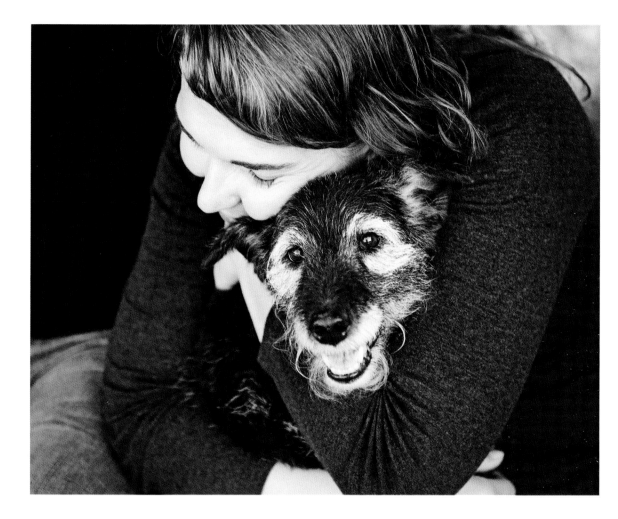

JOY sessions

SARAH BETH

Anyone who's owned a pet knows they can be one of life's greatest companions, sharing their love and loyalty in ways we could never have imagined. Minneapolis-based photographer Sarah Beth captures our bond with animals in her beautiful portraits. Her series *Joy Sessions* shows terminally ill or elderly pets shortly before their deaths.

"For so many people, their pets mean the world to them, and I want to provide an opportunity to capture what makes them so special, especially in such a difficult time," she says. "These sessions really are for people who want to celebrate the happiness—the joy—their pets have brought to their lives."

Sarah hopes that people feel the love that flows from these images. "I'm trying to capture little moments of the relationships we share with our pets, to remember certain expressions, or how they played, or gave kisses, or what their fur felt like. So many people have told me how moved they are by some of these images that they've been brought to tears by a picture of someone they've never met. I think by seeing a beautiful image of someone who clearly and unabashedly loves their animals, to see that bond through touch, smiles, glances: it reminds us of ourselves. Pet owners can universally relate to the gravity of these relationships, and the immense loss that comes after their all-too-short lives."

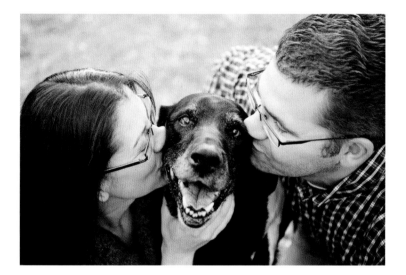

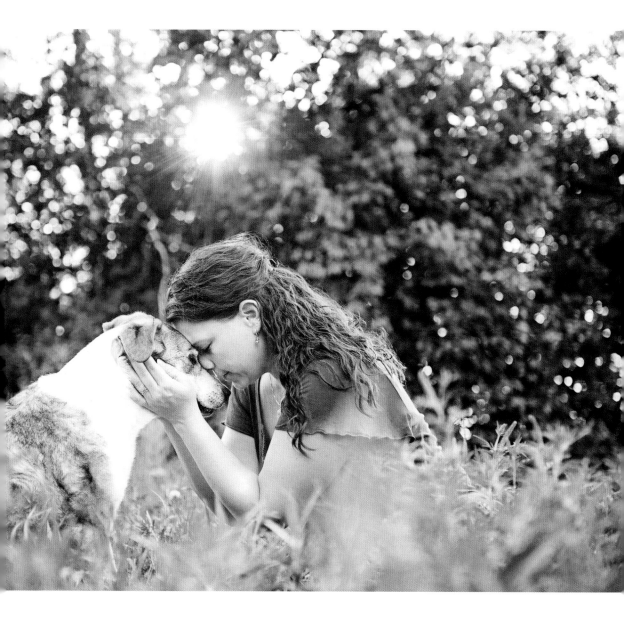

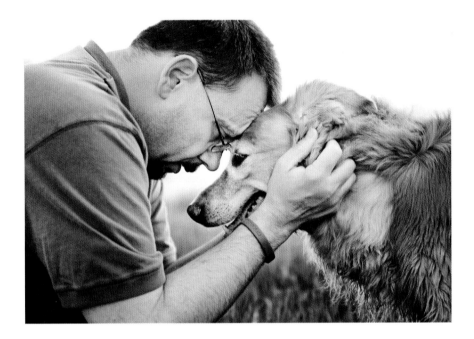

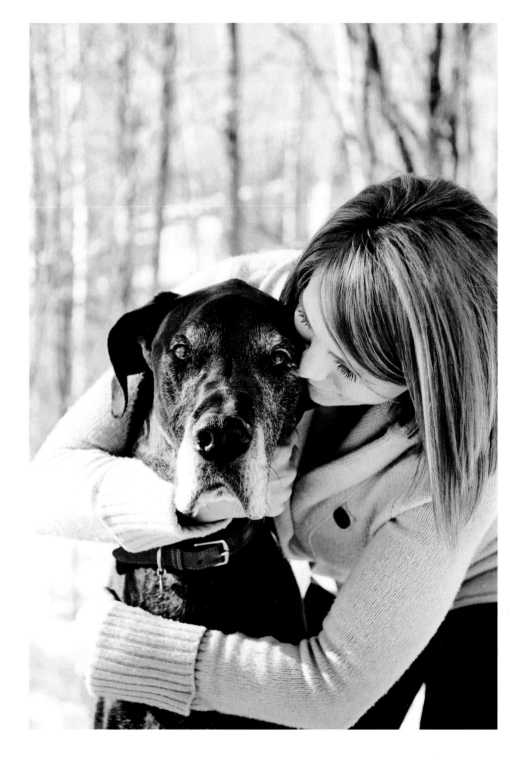

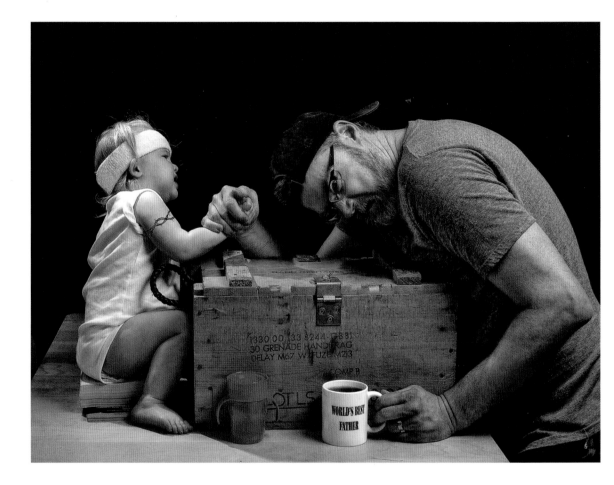

THE "World's Best FATHER"

DAVE ENGLEDOW

With his "World's Best Father" mug in tow, Washington, D.C.–based photographer Dave Engledow creates imaginative photos of himself and his young daughter, Alice Bee, in some truly hilarious situations—such as a photo of his tiny tot vacuuming the floor while her dad sips coffee from the comfort of their couch, or of her screaming for her dad, while he wears noise-canceling headphones and reads his copy of *Twilight*.

"Since the birth of our daughter, Alice Bee, in December of 2010, the majority of my inspiration has stemmed from creatively documenting the first moments of her life in our family," Dave says. The ongoing photo series, aptly titled *World's Best Father*, continues to churn out new Photoshopped images of the father-daughter duo in comical scenes that showcase the dazed, sleep-deprived dad with his daring little daughter.

"The thing I've learned most about being a father is how little I know about being one," Dave says. "I feel like I fail at some aspect of it every single day. But in the midst of all the failings, my overall goal remains constant: make sure that Alice Bee always knows she is loved, supported, and safe."

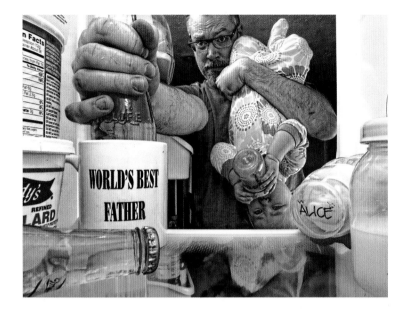

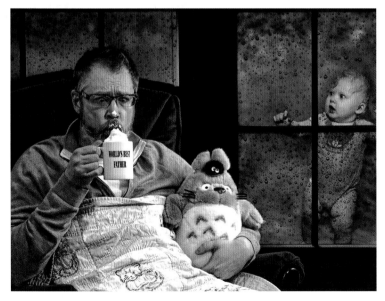

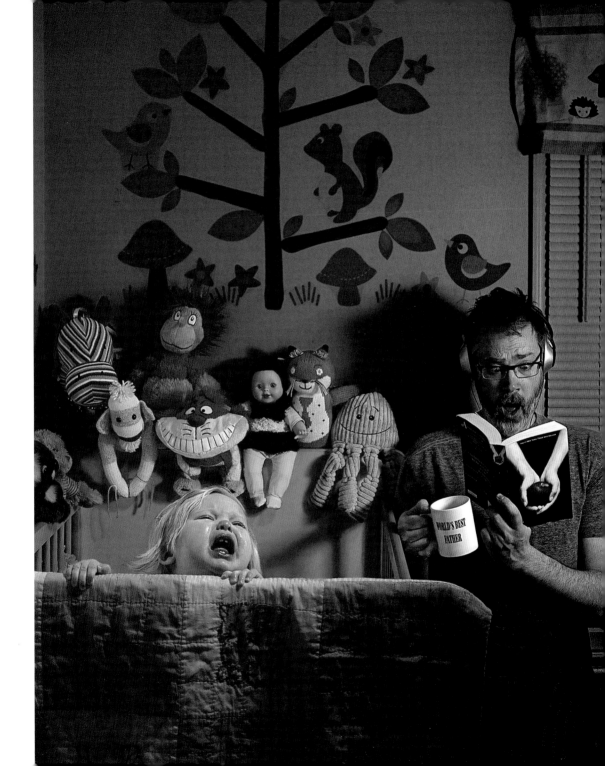

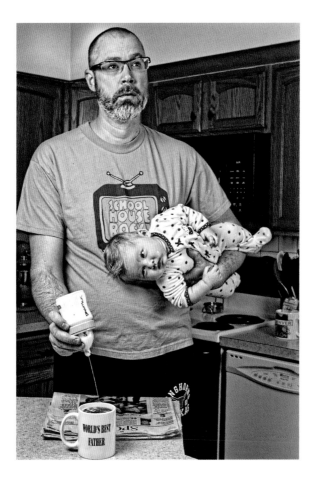

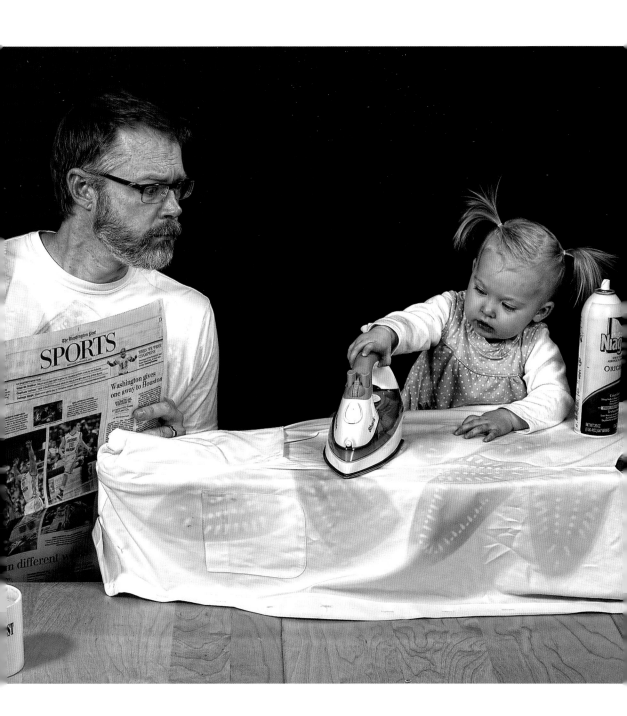

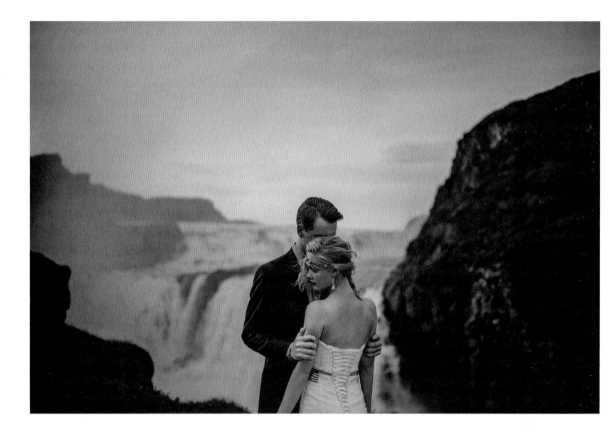

Eloping
IN
ICELAND

GABE McCLINTOCK

Sarah and Josh Walk had planned to have a simple wedding with their family and friends in their home state of Ohio, but at the last minute the couple changed their minds—and decided to elope in Iceland. "It's what we had really wanted to do from the beginning, but were too afraid to actually set in stone," they explain. "We wanted an adventure and a once-in-a-lifetime experience, and we had always known that Iceland would be exactly the place that could exceed our expectations."

Set against an incredibly stunning backdrop that included roaring water-falls, grand mountains, rocky landscapes, and lush plains, wedding photographer Gabe McClintock's portraits took advantage of every dramatic vista. "I think this rawness and feeling of isolation worked so well for Sarah and Josh's images," says Gabe. "They had this beautiful connection to each other, and to be placed in an environment where you feel you're the only person for a hundred miles creates this deeper sense of connection to the one you're holding."

Sarah herself is a wedding photographer, so she knew exactly what she wanted and had a good sense of what Gabe was looking for, be it a "pocket of light" or a "sense of movement."

During the shoot, Gabe noted the couple's remarkable connection. "It wasn't a show or an act. There was no one around to judge them or for them to perform for. They are truly in love, and that showed in the images.

"For me, the decision to go halfway around the world, with just the two of them, was perfection," Gabe says. "They wanted to celebrate each other with each other. They wanted the day to be about them and their commitment to each other, and I found that beautiful."

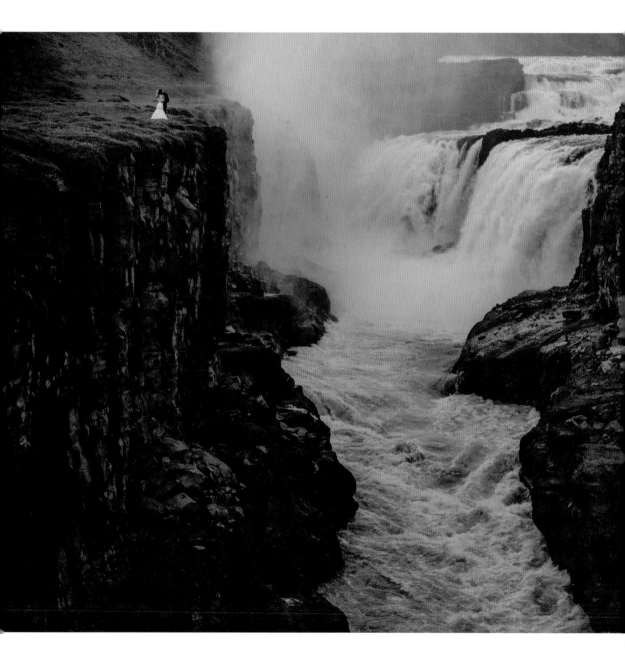

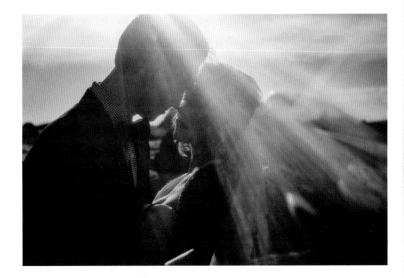

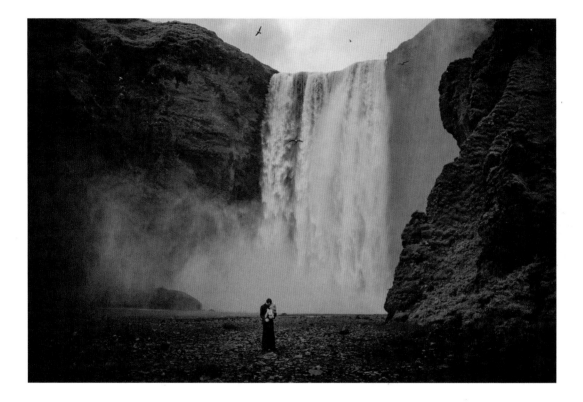

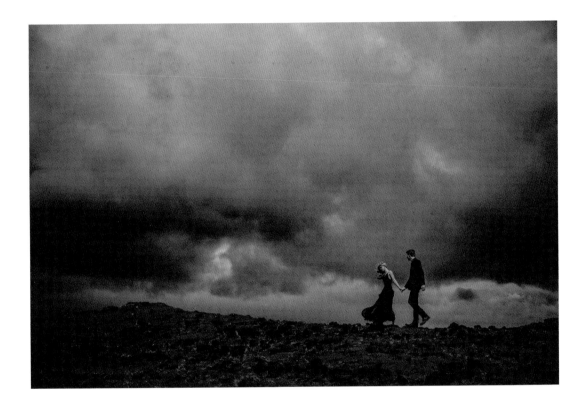

Art Credits